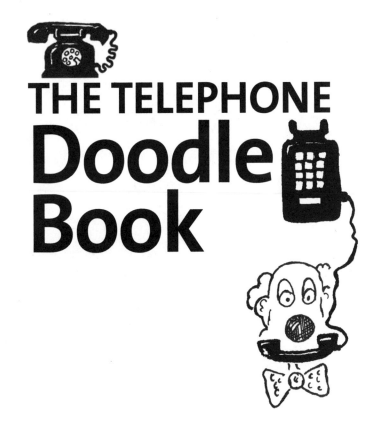

# THE TELEPHONE
# Doodle
# Book

# THE TELEPHONE
# Doodle Book

ANDREW PINDER

GOTHAM
BOOKS

GOTHAM BOOKS
Published by Penguin Group (USA) Inc.
375 Hudson Street, New York, New York 10014, U.S.A.
Penguin Group (Canada), 90 Eglinton Avenue East, Suite 700, Toronto, Ontario M4P 2Y3, Canada (a division of Pearson Penguin Canada Inc.) • Penguin Books Ltd, 80 Strand, London WC2R 0RL, England • Penguin Ireland, 25 St Stephen's Green, Dublin 2, Ireland (a division of Penguin Books Ltd) • Penguin Group (Australia), 250 Camberwell Road, Camberwell, Victoria 3124, Australia (a division of Pearson Australia Group Pty Ltd) • Penguin Books India Pvt Ltd, 11 Community Centre, Panchsheel Park, New Delhi – 110 017, India • Penguin Group (NZ), 67 Apollo Drive, Rosedale, North Shore 0632, New Zealand (a division of Pearson New Zealand Ltd) • Penguin Books (South Africa) (Pty) Ltd, 24 Sturdee Avenue, Rosebank, Johannesburg 2196, South Africa

Penguin Books Ltd, Registered Offices: 80 Strand, London WC2R 0RL, England

First published in Great Britain in 2009 by Michael O'Mara Books Limited.

Published by Gotham Books, a member of Penguin Group (USA) Inc.

First printing, July 2010
10   9   8   7   6   5   4   3   2   1

LIBRARY OF CONGRESS CATALOGING-IN-PUBLICATION DATA has been applied for.

ISBN 978-1-592-40560-2

Printed in the United States of America

While the author has made every effort to provide accurate telephone numbers and Internet addresses at the time of publication, neither the publisher nor the author assumes any responsibility for errors, or for changes that occur after publication. Further, the publisher does not have any control over and does not assume any responsibility for author or third-party Web sites or their content.

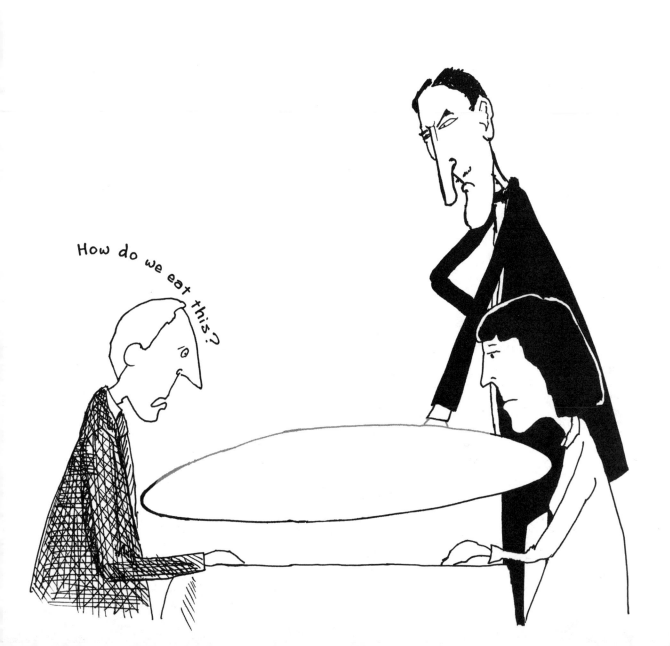

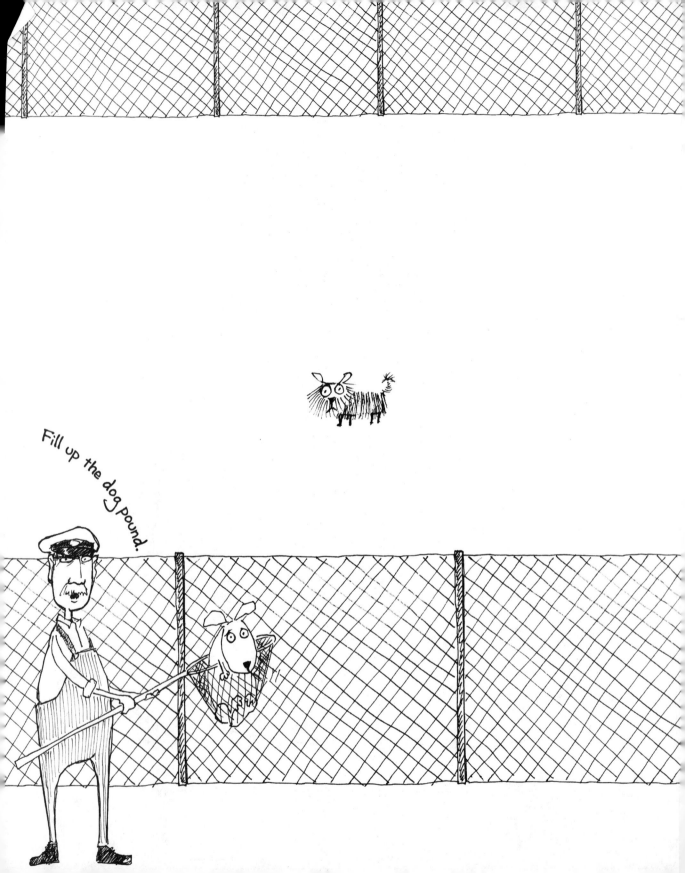

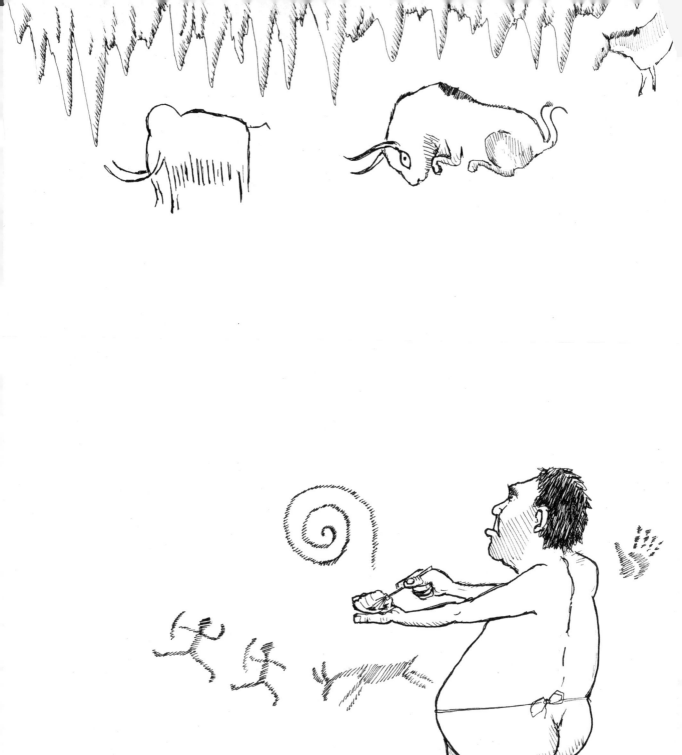

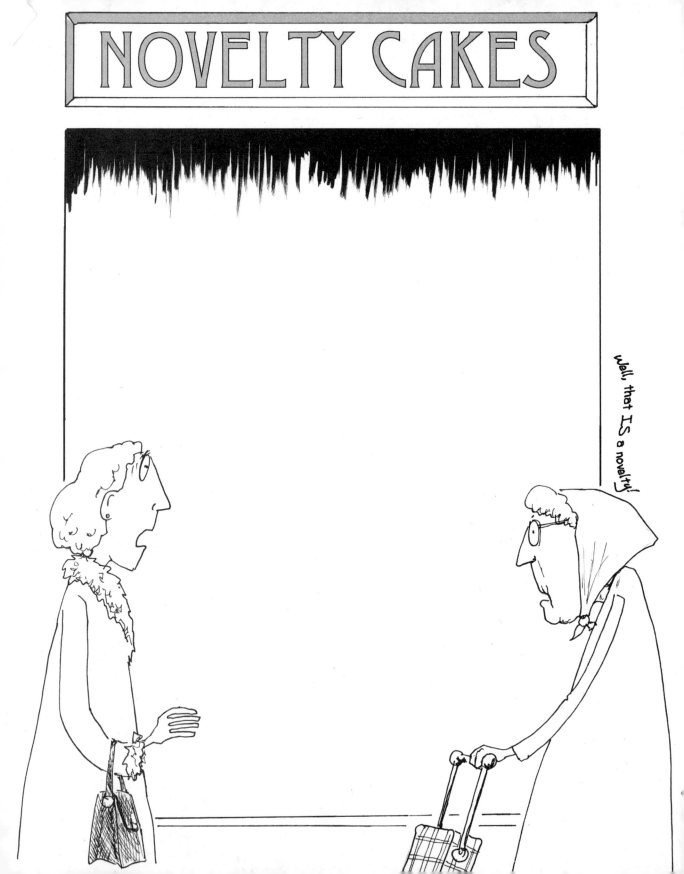

Do something about these plain butterflies.

Alien autopsy

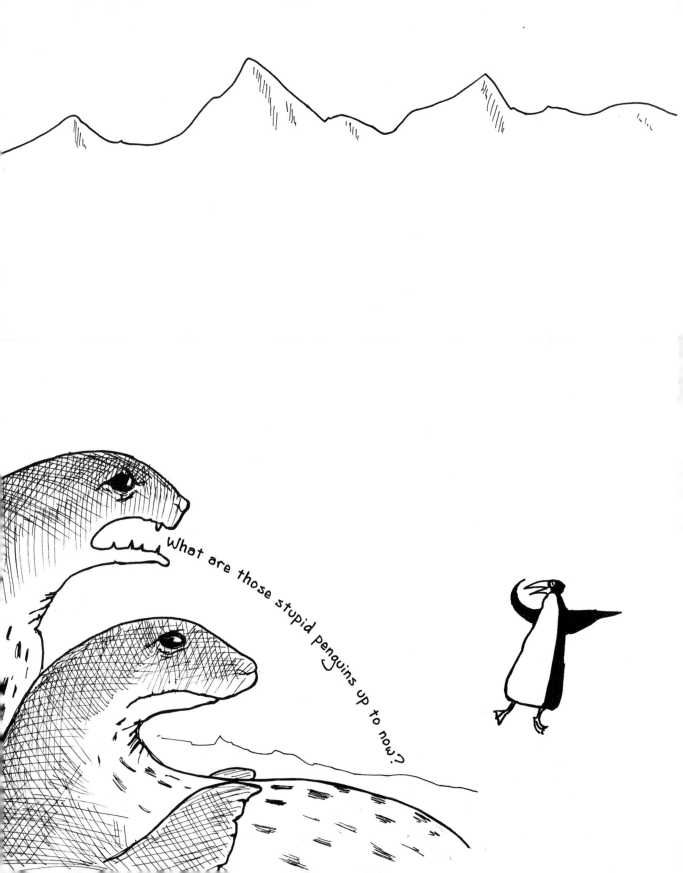

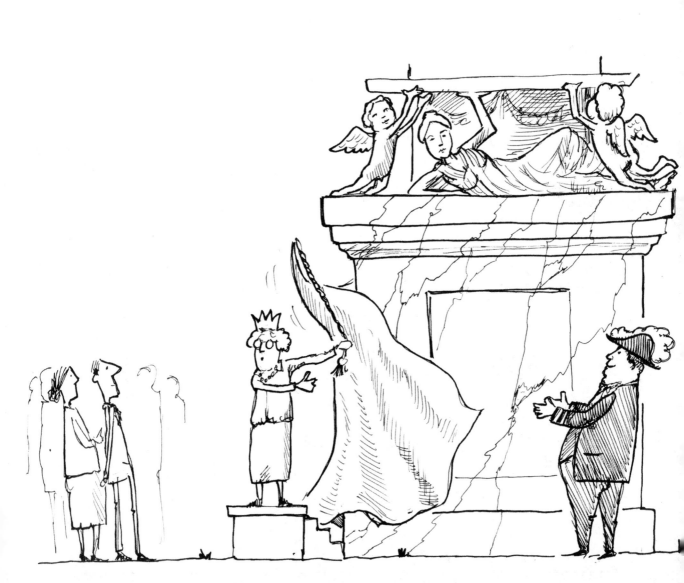

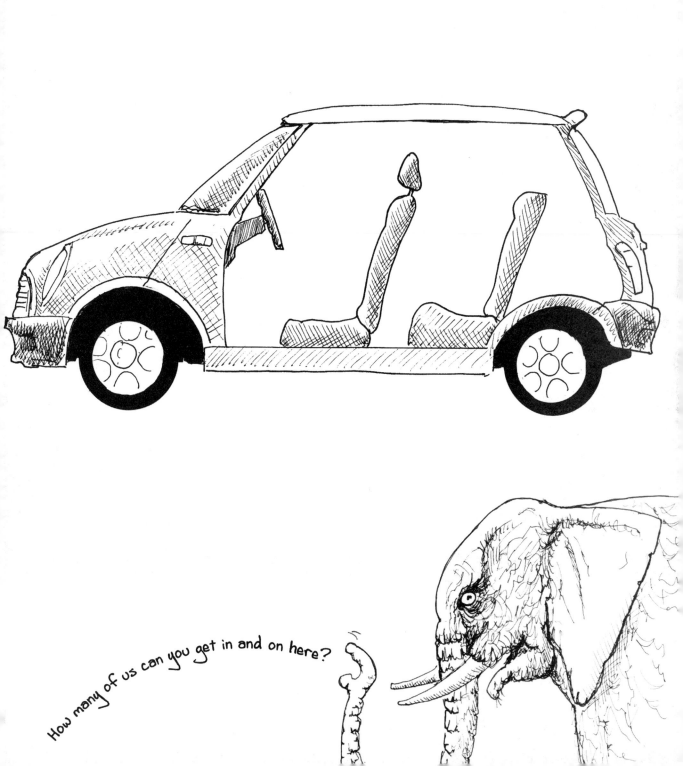

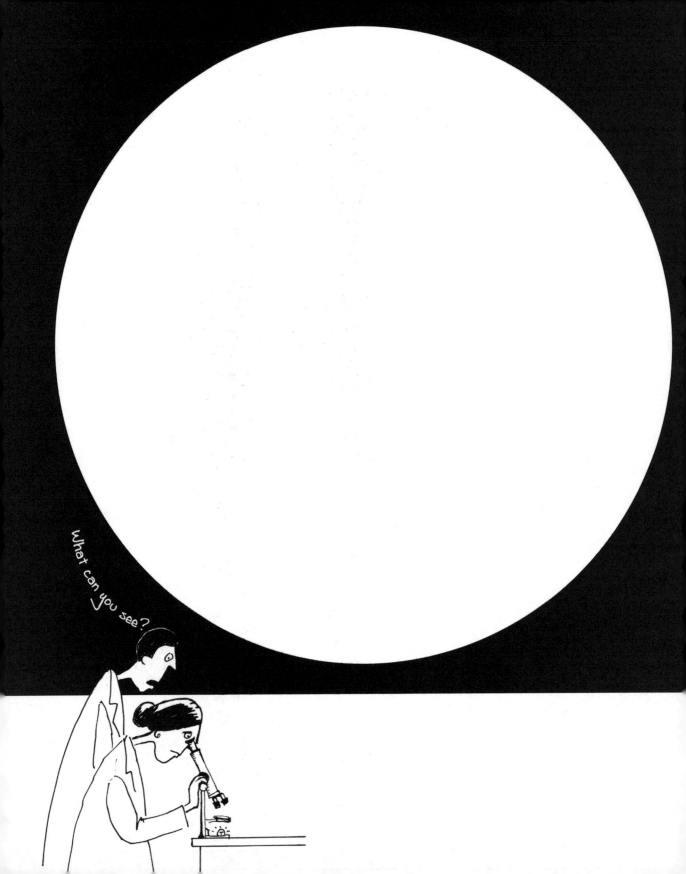

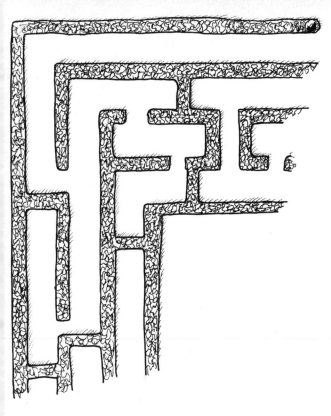

Finish
the maze.

| | | | |
|---|---|---|---|
| [glyph] | A | [glyph] | N |
| [glyph] | B | [glyph] | O |
| [glyph] | C | [glyph] | P |
| [glyph] | D | [glyph] | Q |
| [glyph] | E | [glyph] | R |
| [glyph] | F | [glyph] | S |
| [glyph] | G | [glyph] | T |
| [glyph] | H | [glyph] | TH |
| [glyph] | I | [glyph] | U |
| [glyph] | J | [glyph] | V |
| [glyph] | K | [glyph] | W |
| [glyph] | L | [glyph] | X |
| [glyph] | M | [glyph] | Y |
| | | [glyph] | Z |

Write like an Egyptian.

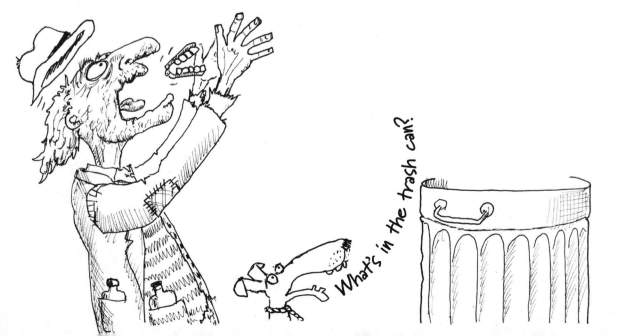

Yeah, I know, but they're good earners.

Fill the page with doves and ravens.

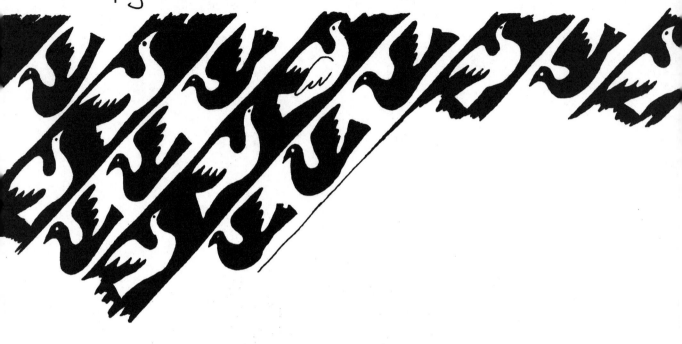

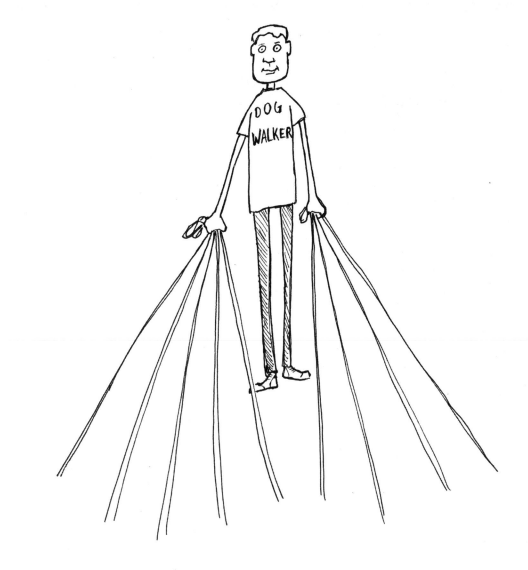

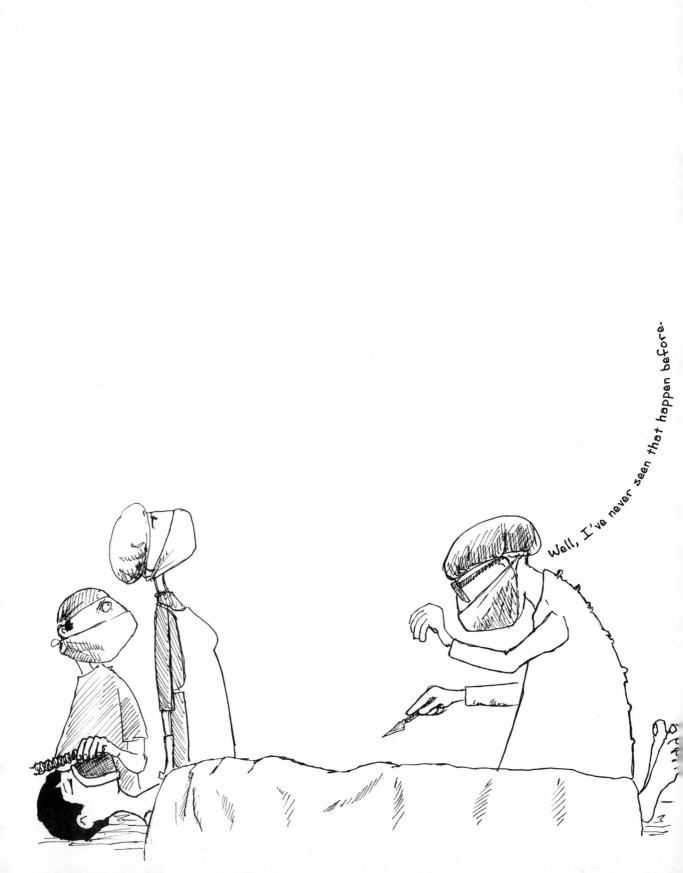

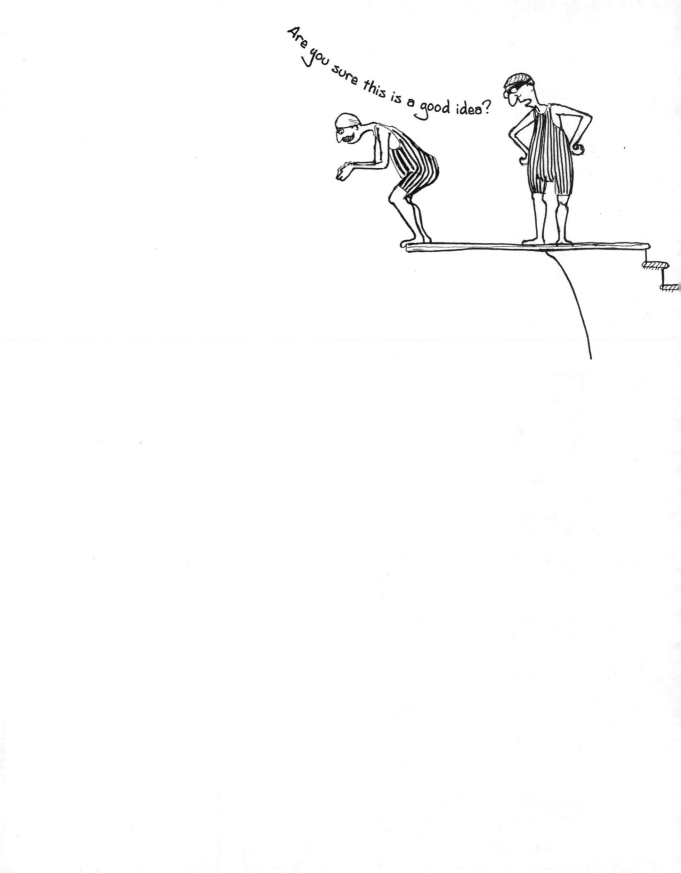

There's always someone who has to go over the top with his crest.

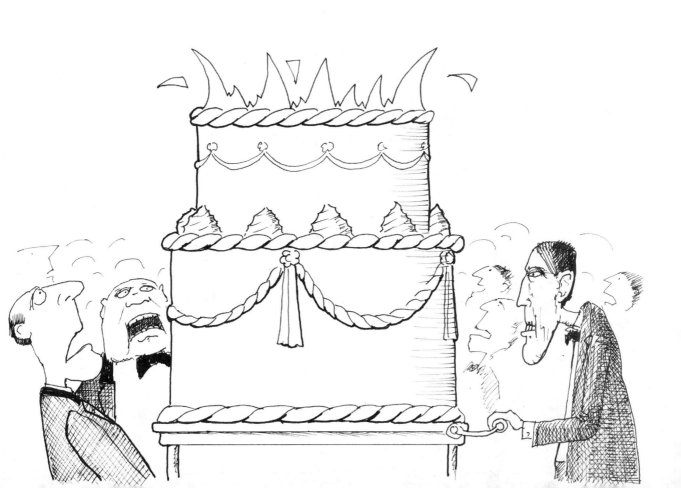

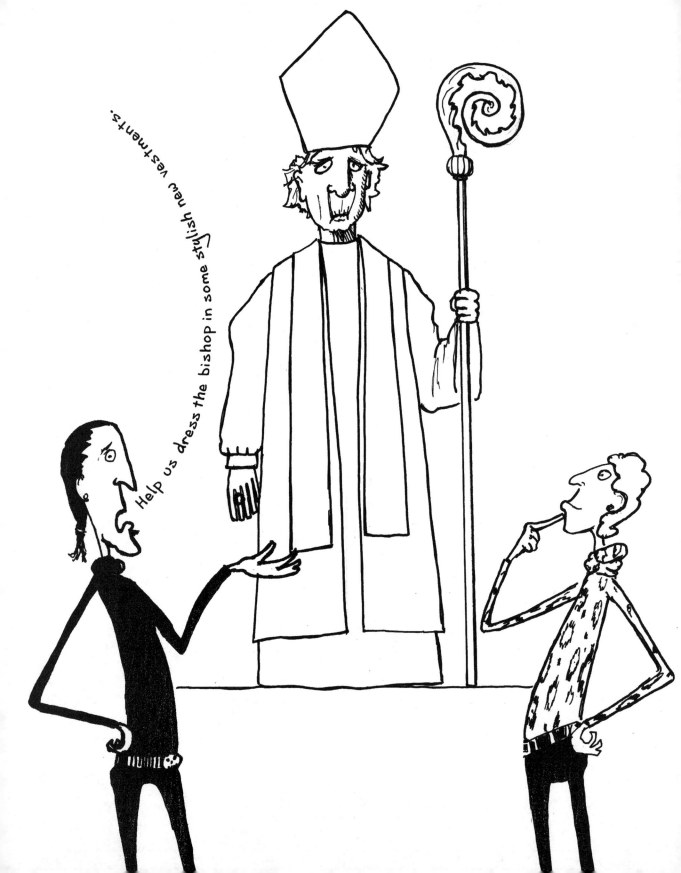

What worries me is, I'm not sure that new one is a bird.

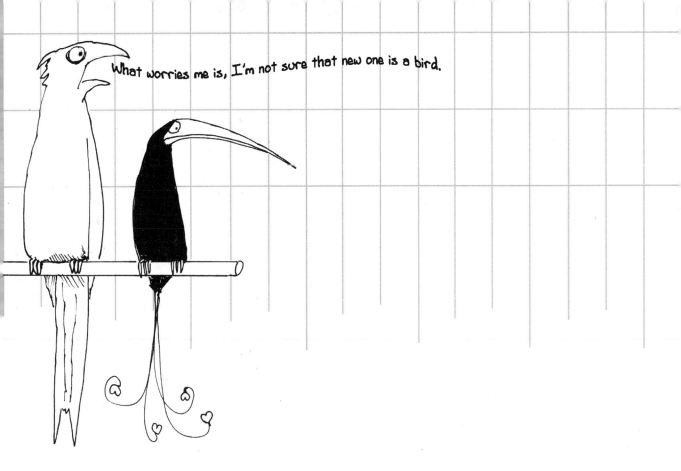

# CONTEMPORARY ART FAIR

THE
WORLD'S
UGLIEST
FISH

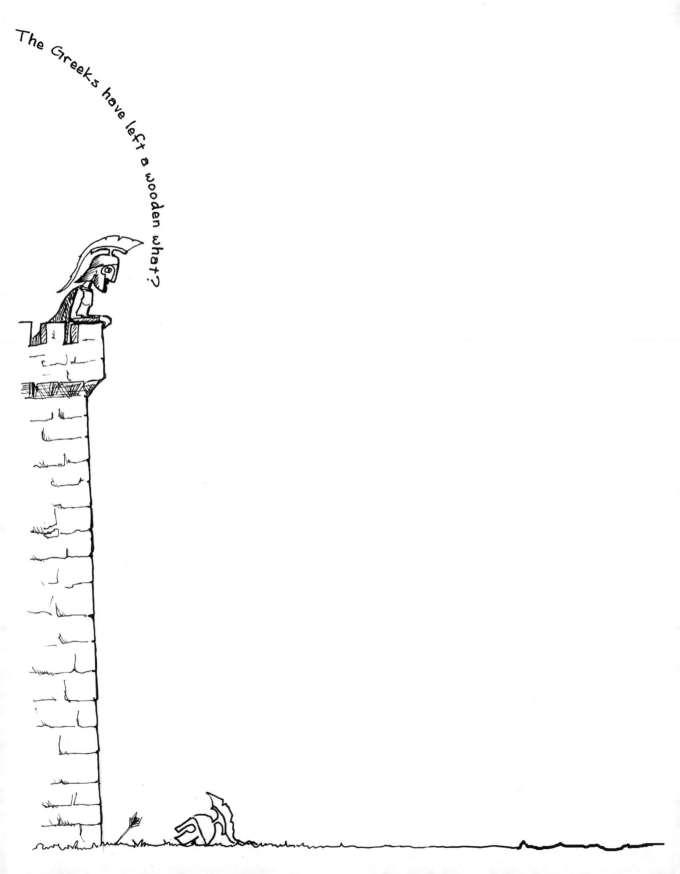

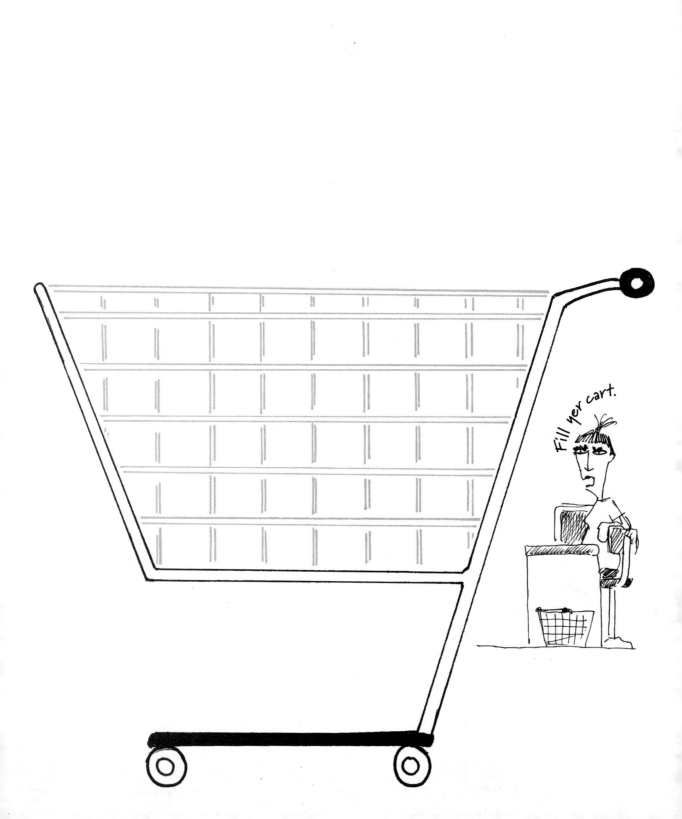

PHOTOGRAPHER
OF
THE
YEAR

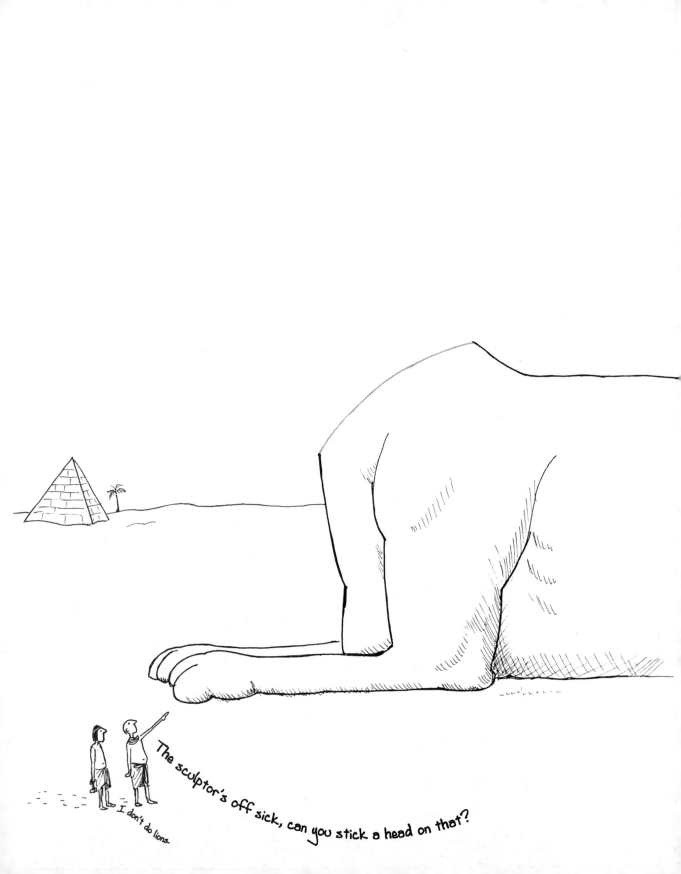

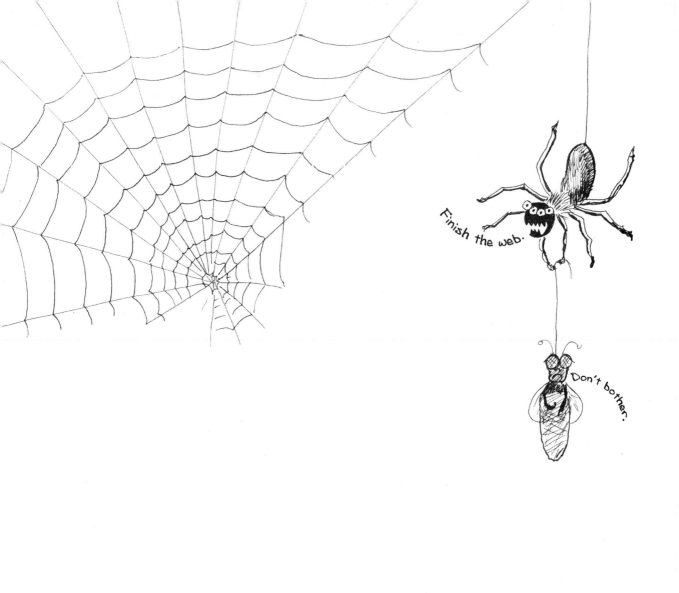

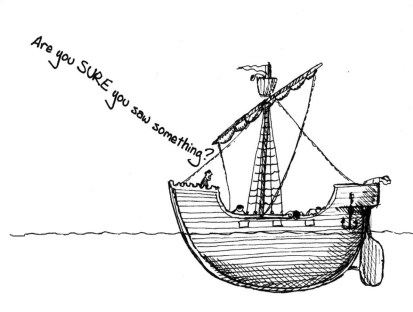

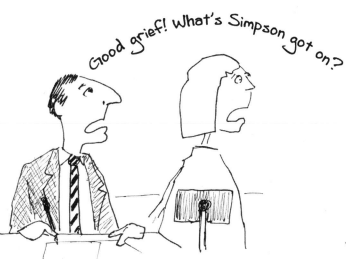

Good grief! What's Simpson got on?

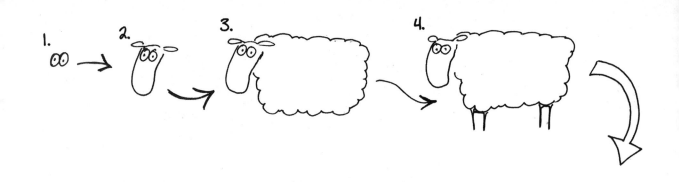

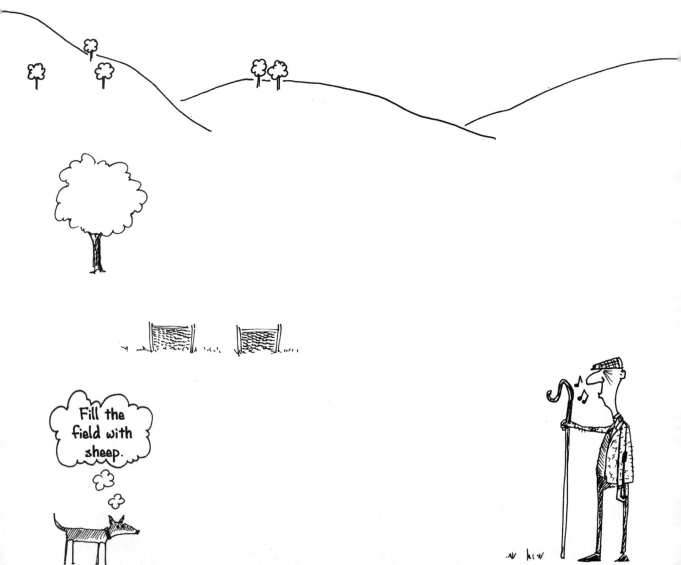

Fill the field with sheep.

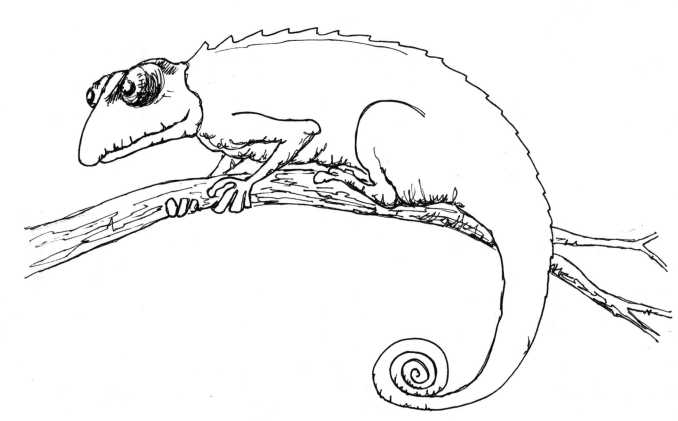

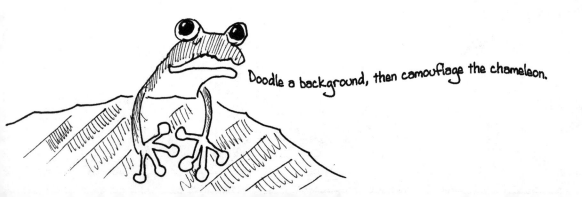

Doodle a background, then camouflage the chameleon.

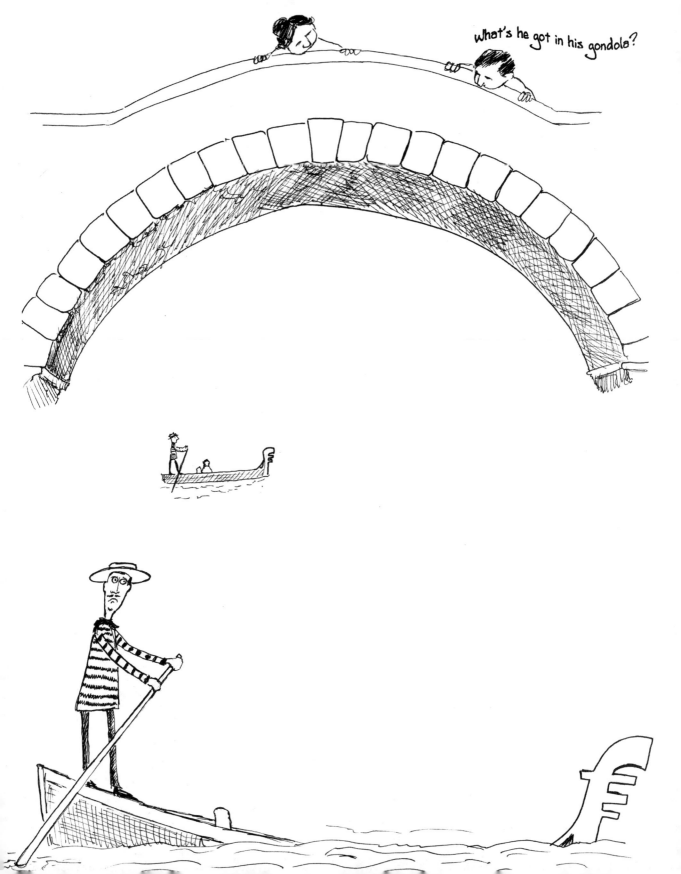

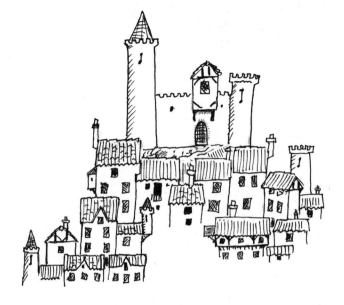

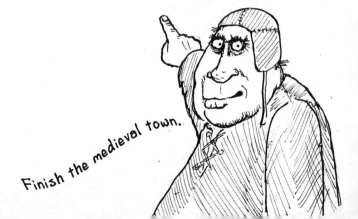

Finish the medieval town.

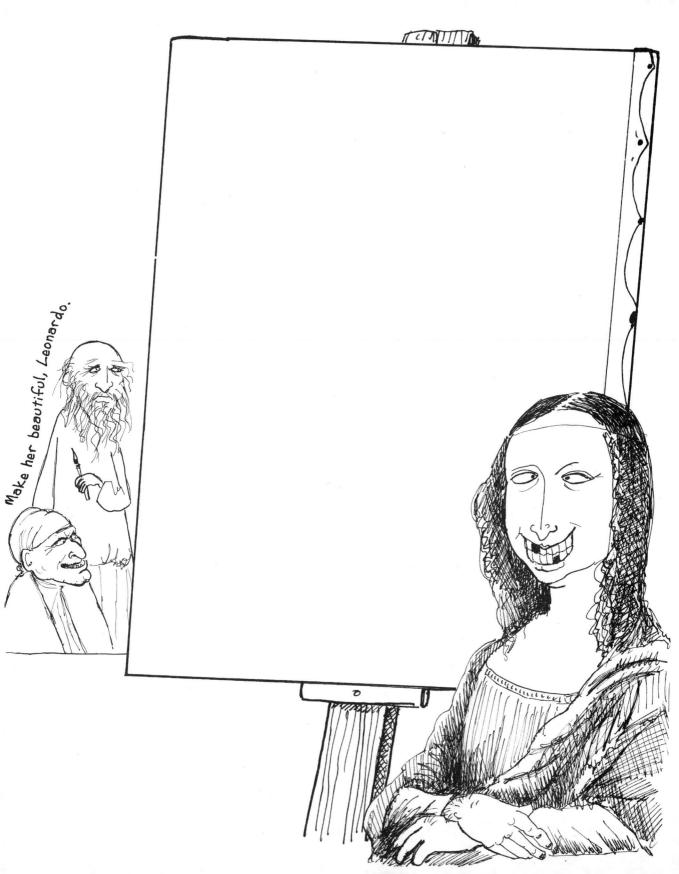

So, that's the new mousetrap.

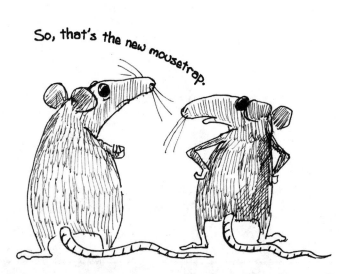

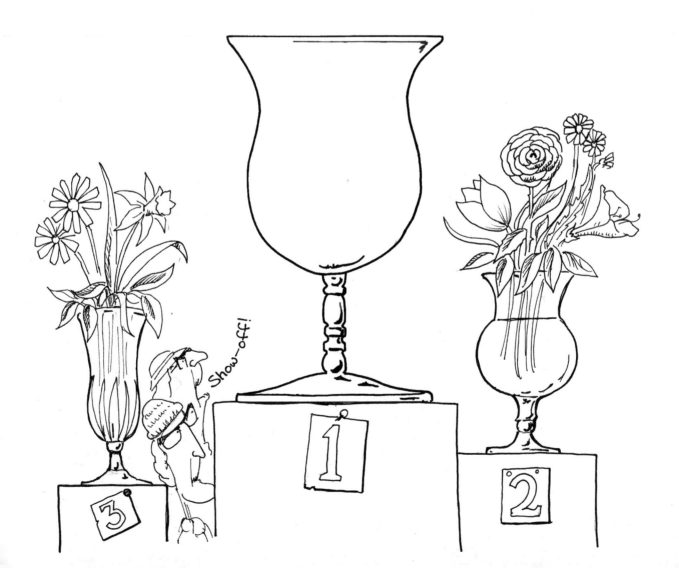

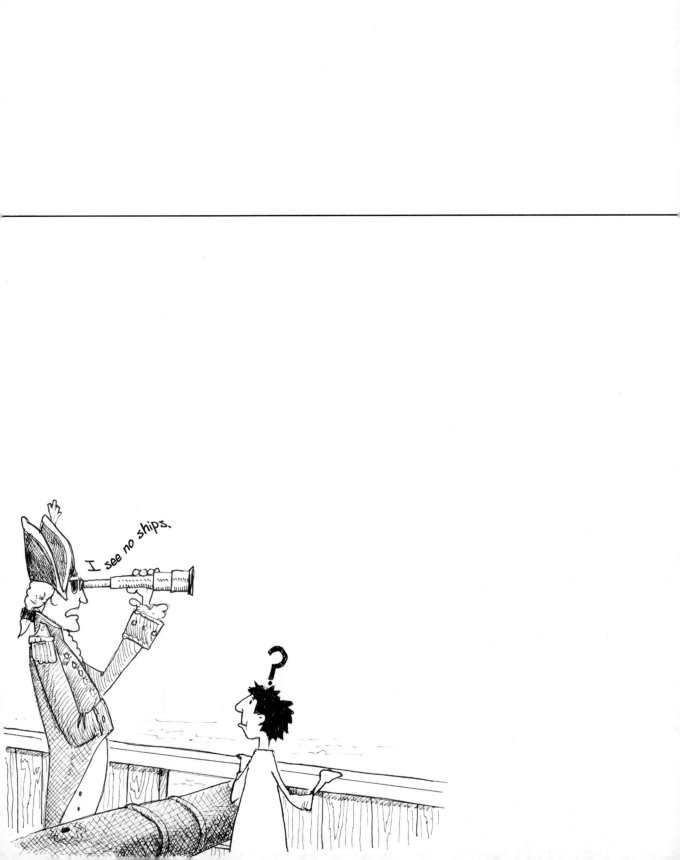

If dogs ruled the world...

If cats ruled the world...

Fill the pond with frogs.

Stock up the fridge.

*Quite ravishing...*

Fill the forest.

What's on TV?

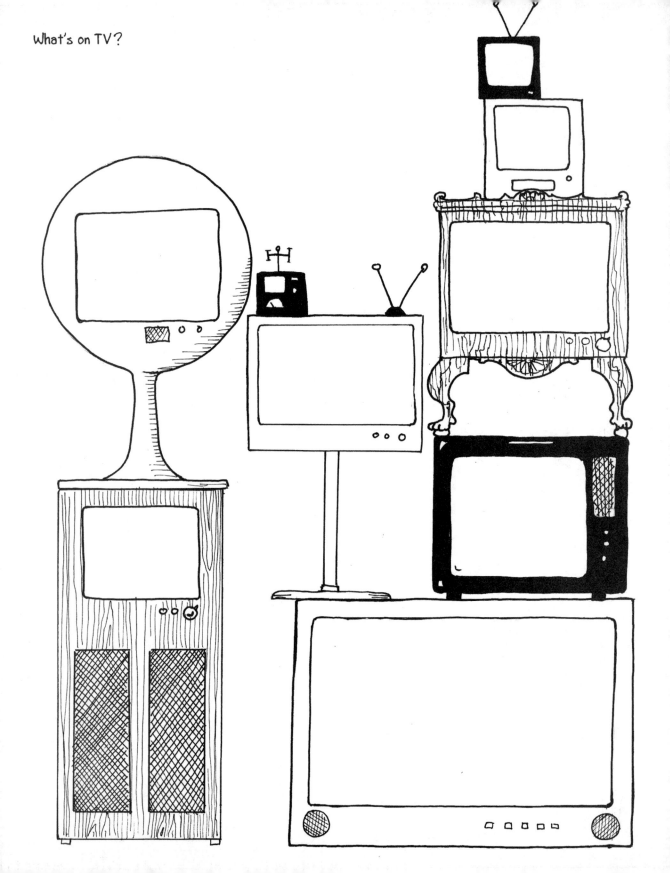

Your turn...

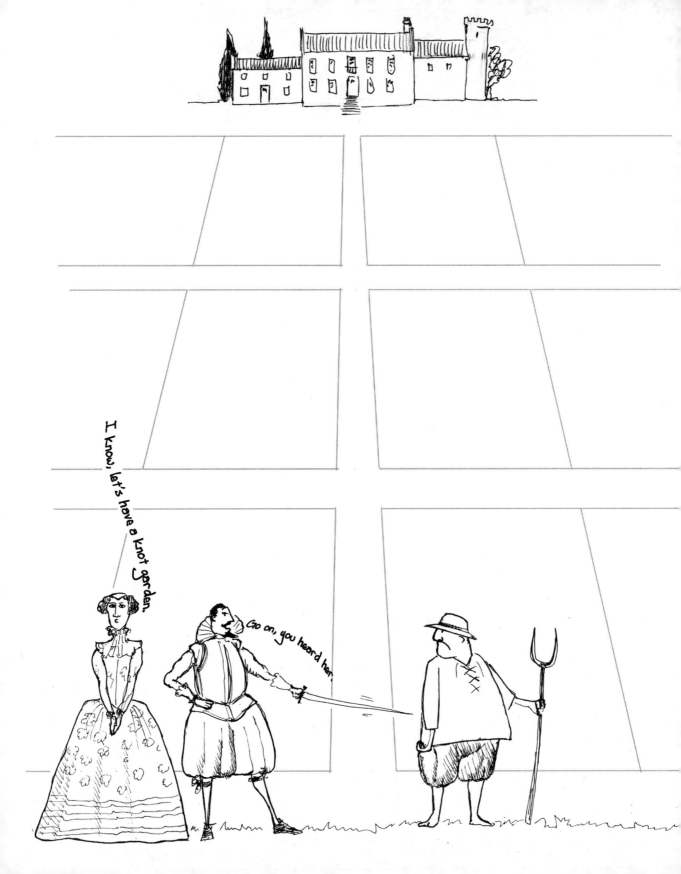

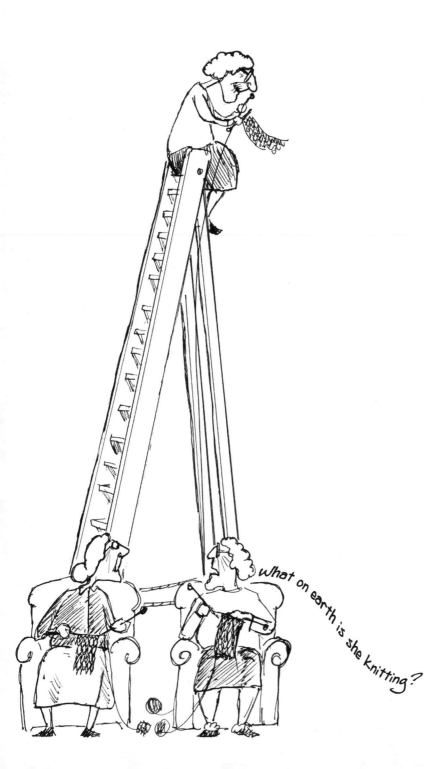

Give us some hair!

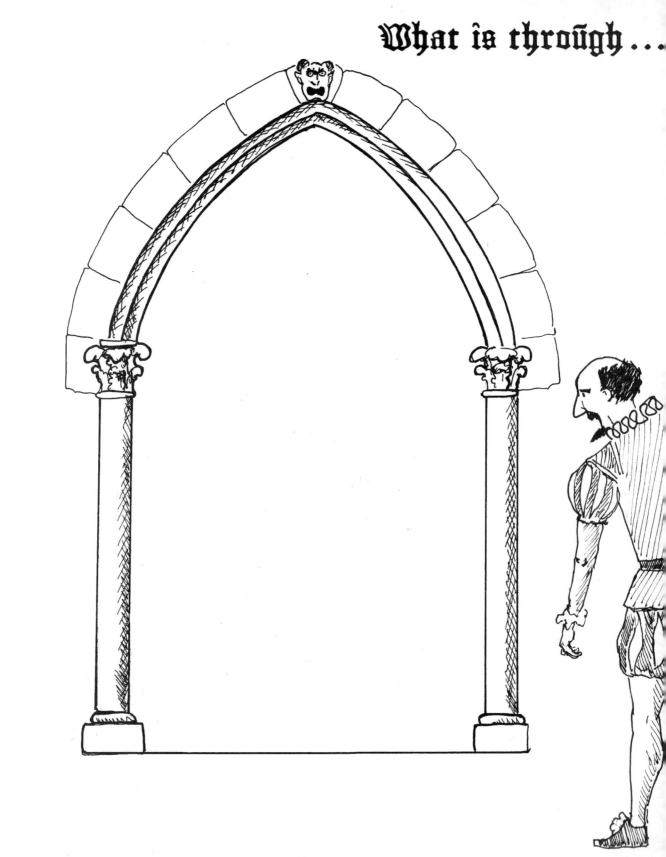

...th☰ d●●rs?

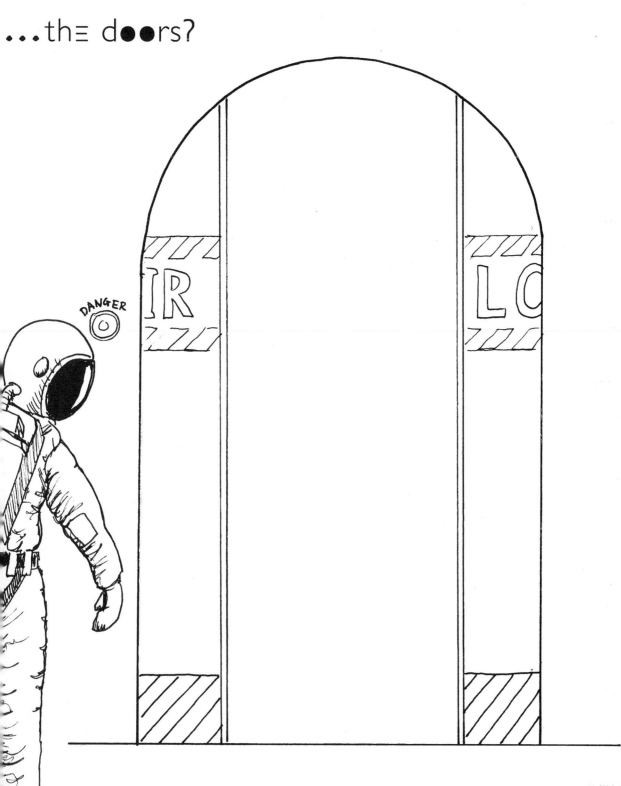

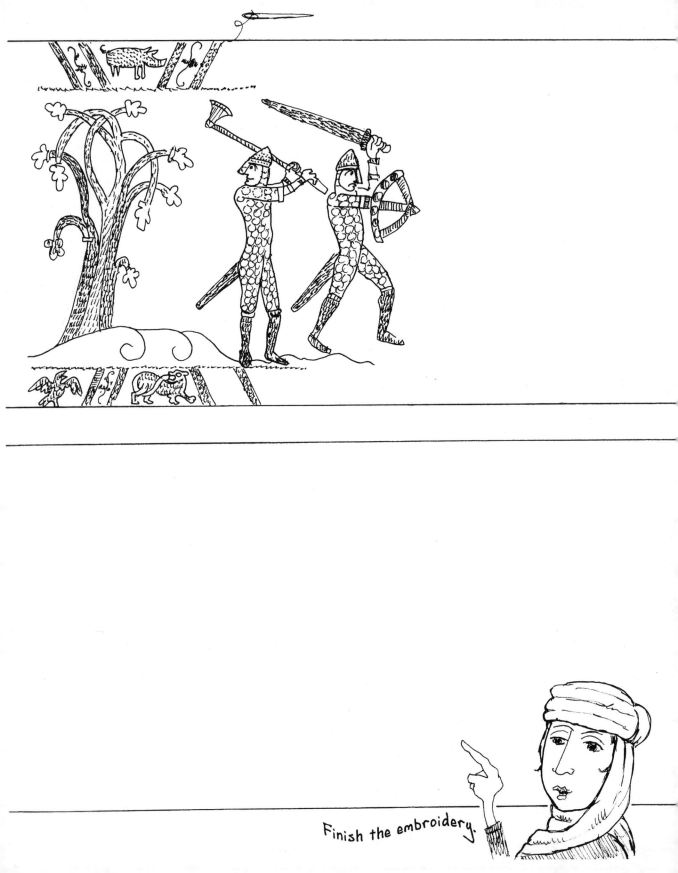

Finish the embroidery.

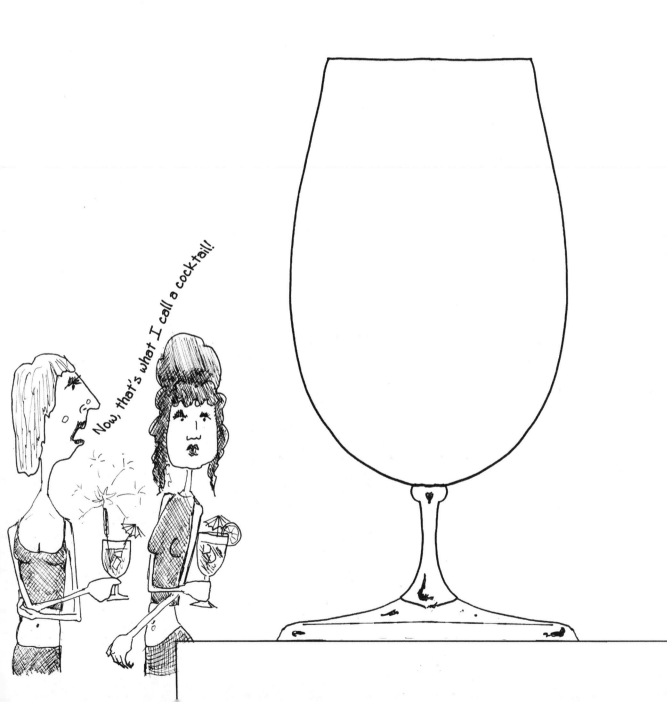

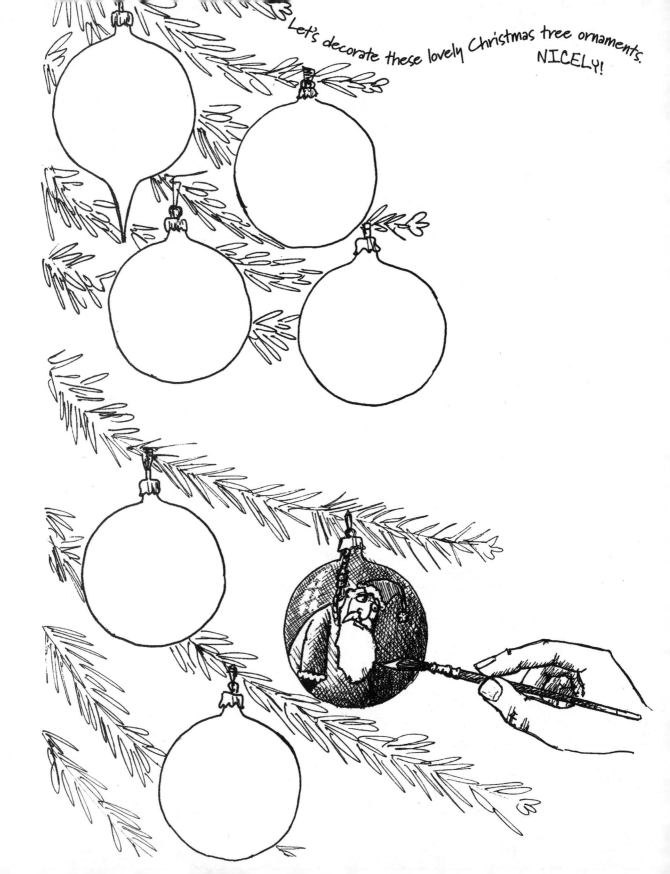

Let's decorate these lovely Christmas tree ornaments.
NICELY!

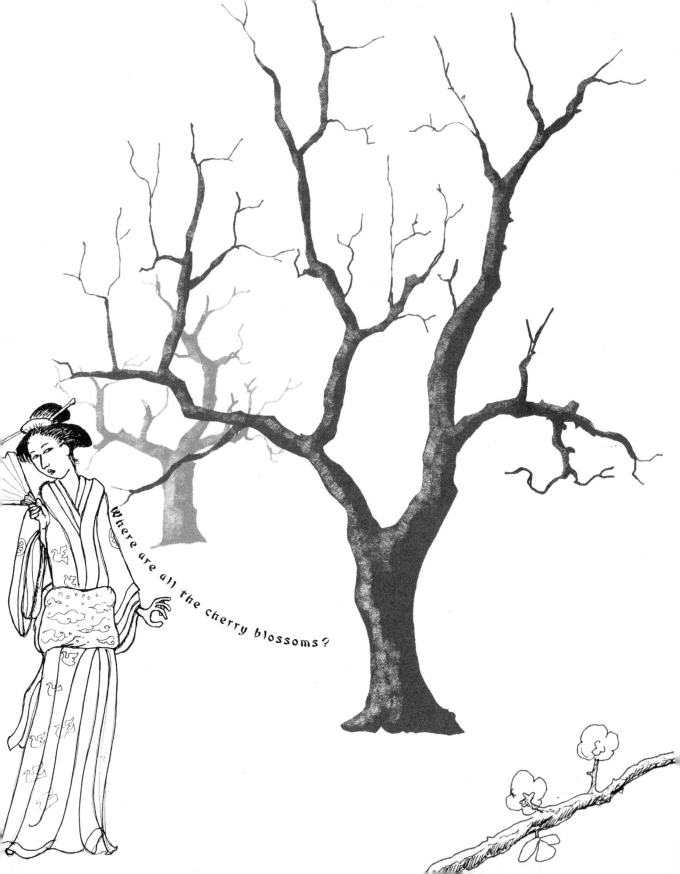

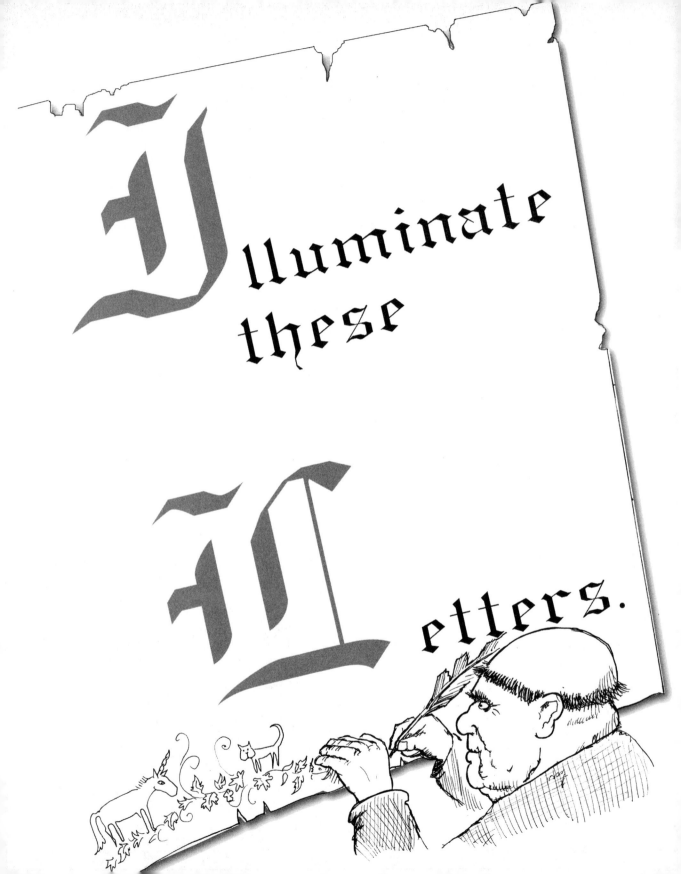

Illuminate these Letters.

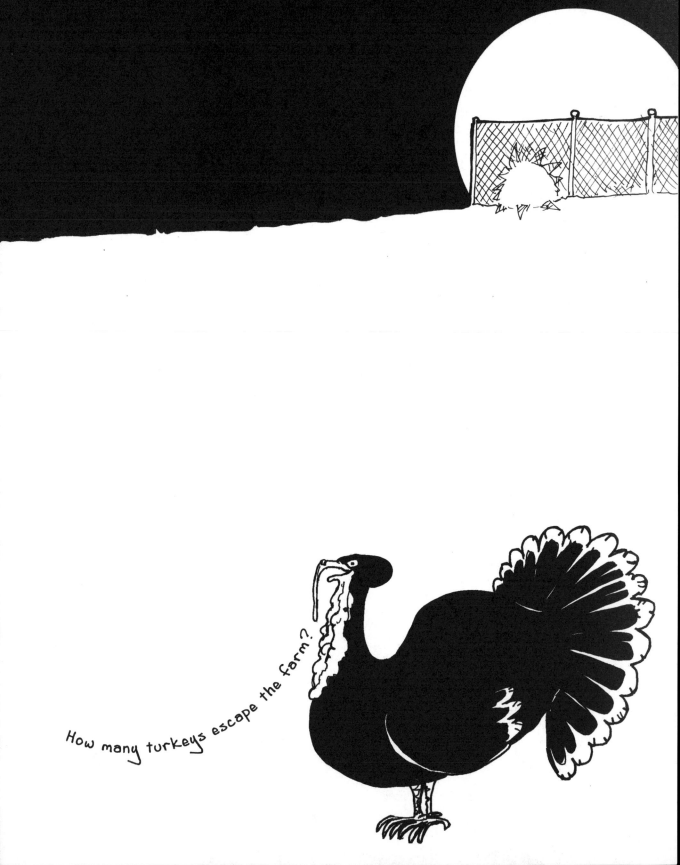

How many turkeys escape the farm?

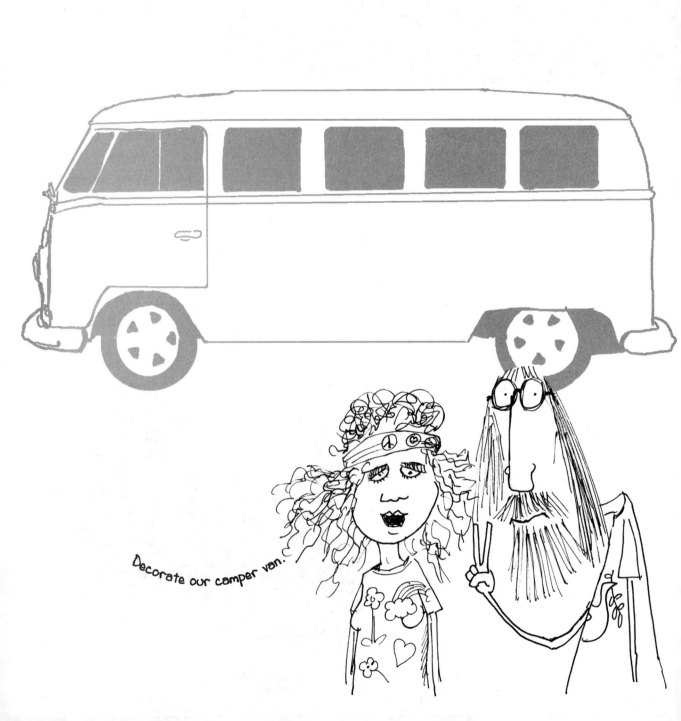

Decorate our camper van.

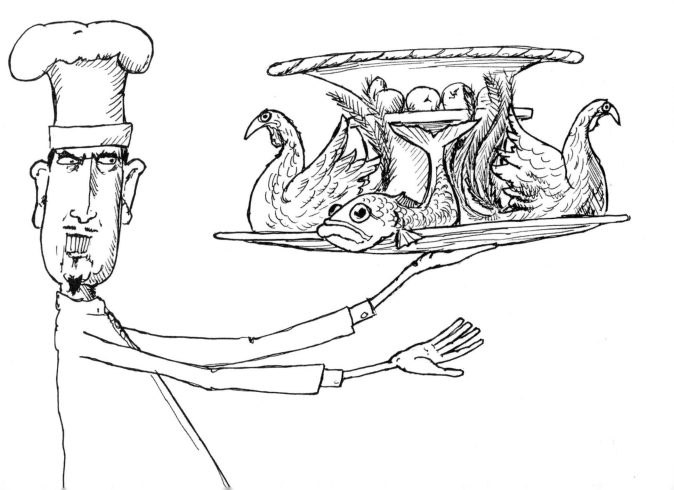

Finish the carpet.

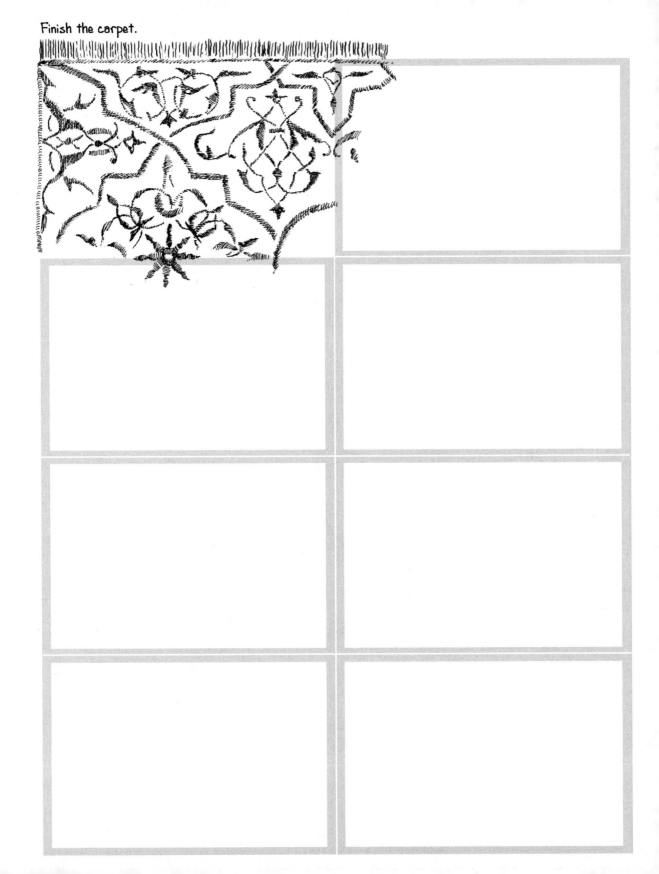

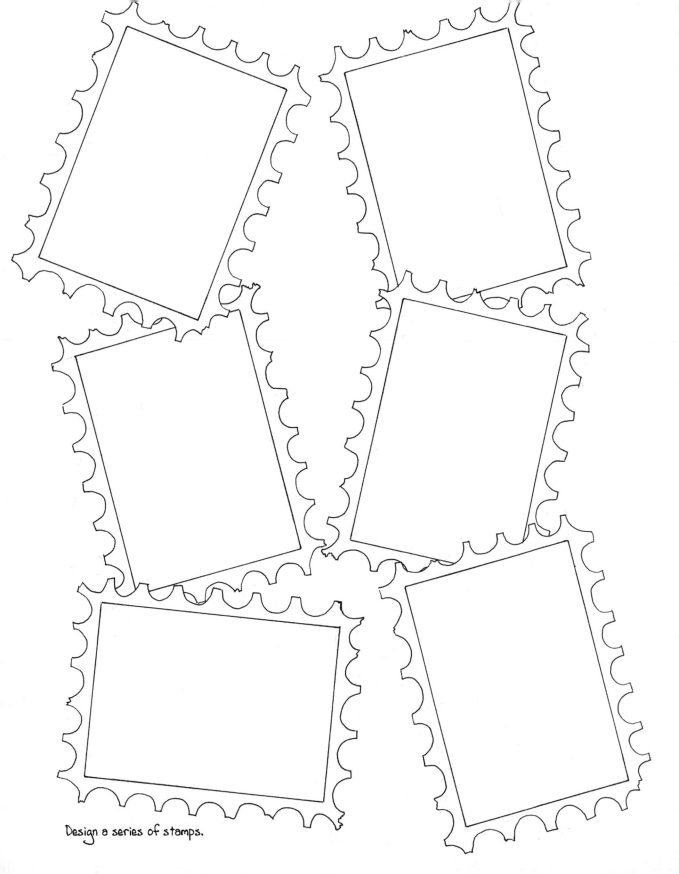

Design a series of stamps.

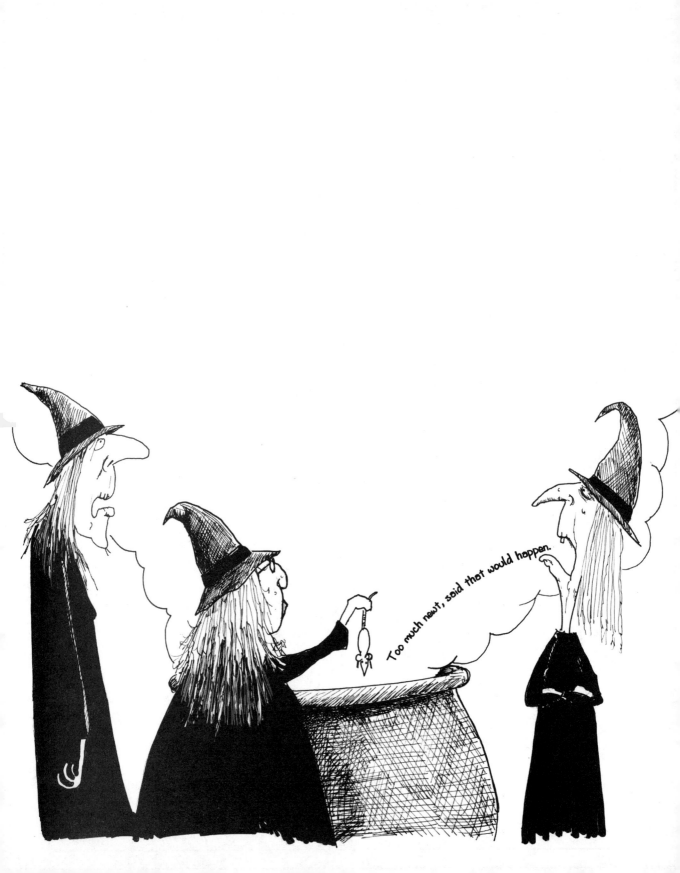

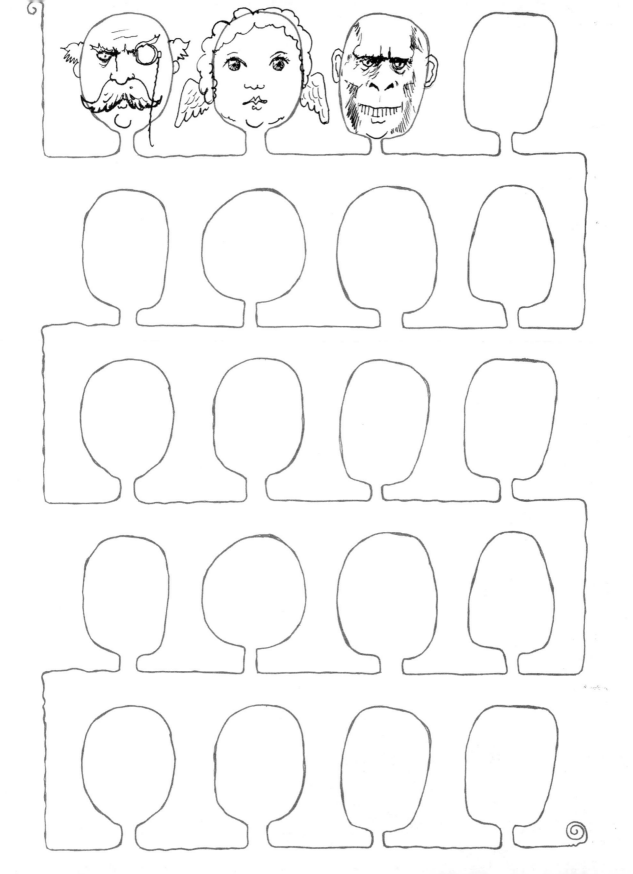

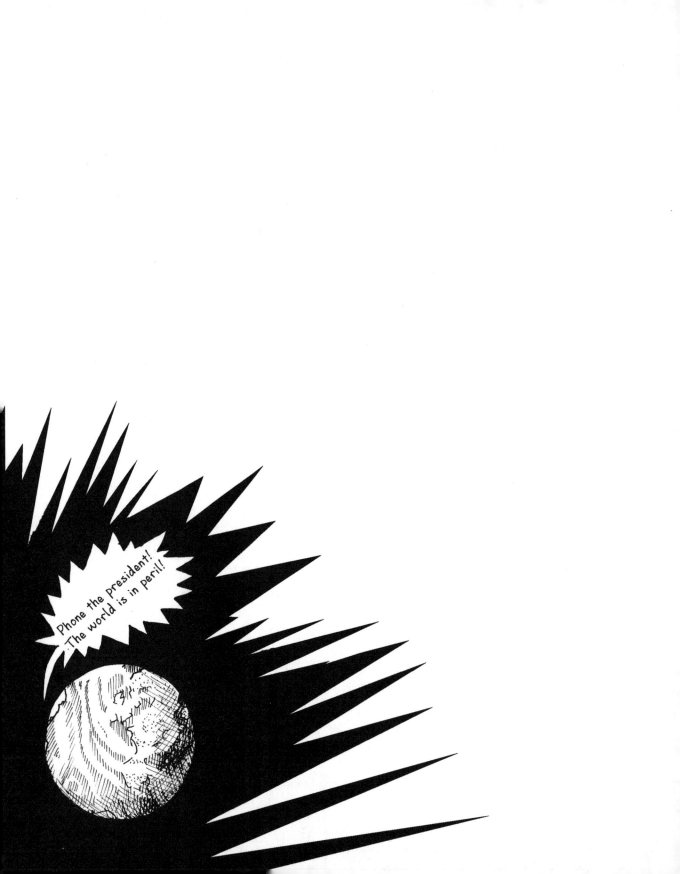

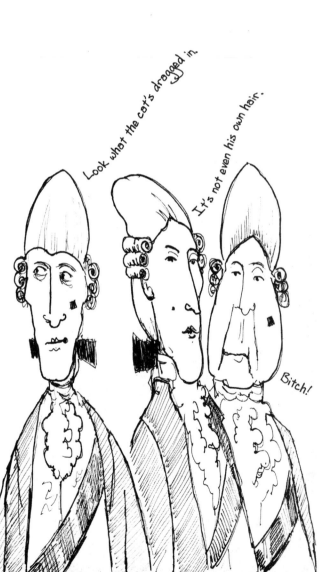

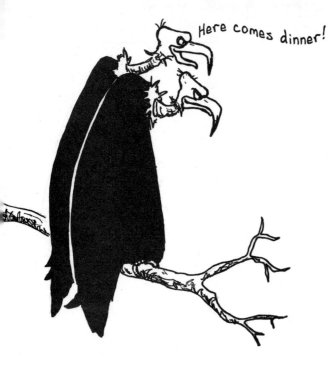

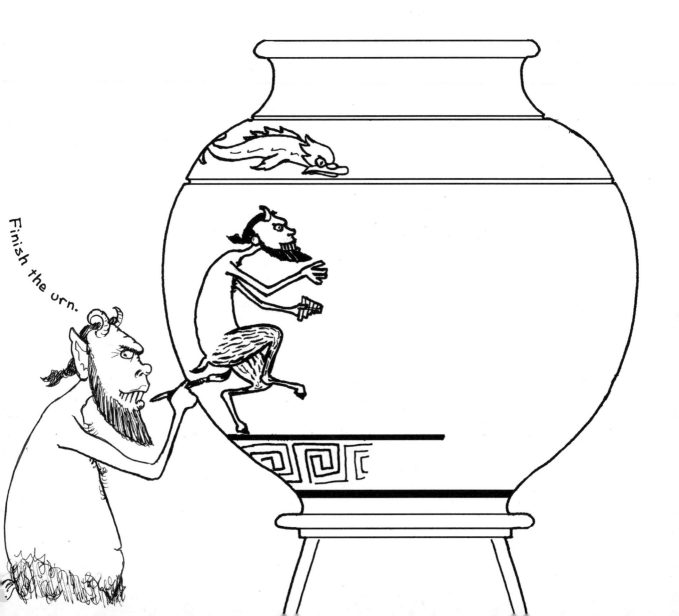

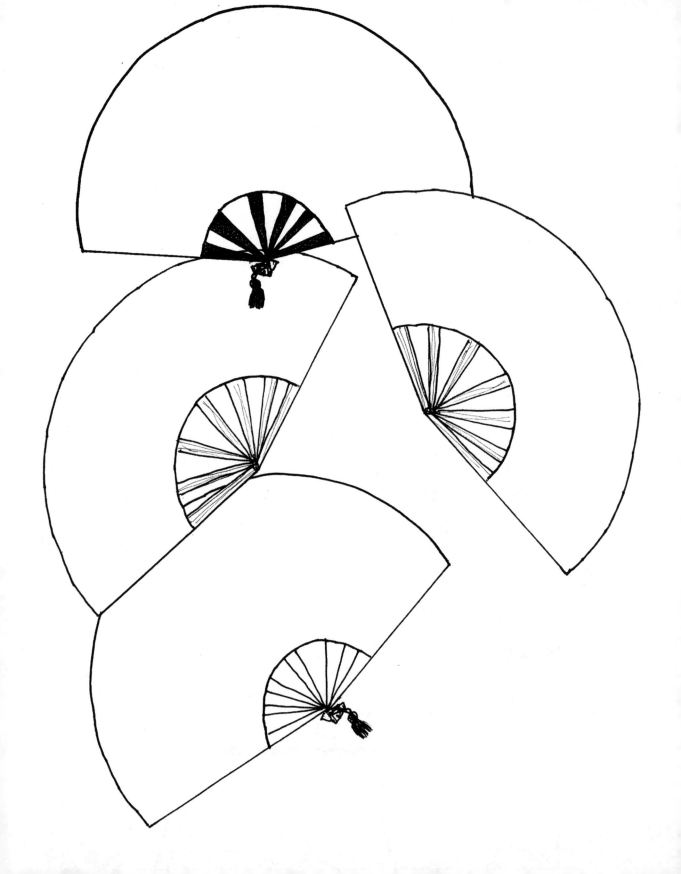

Ufff! What 'orrible plain fans.

Winter | Summer | Winter | Summer | Winter

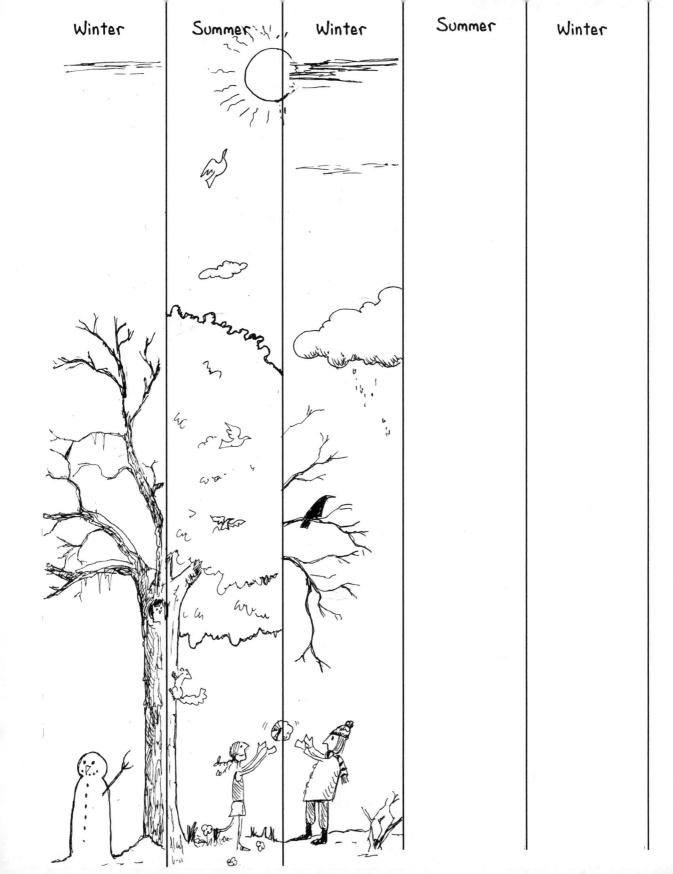

What's playing?

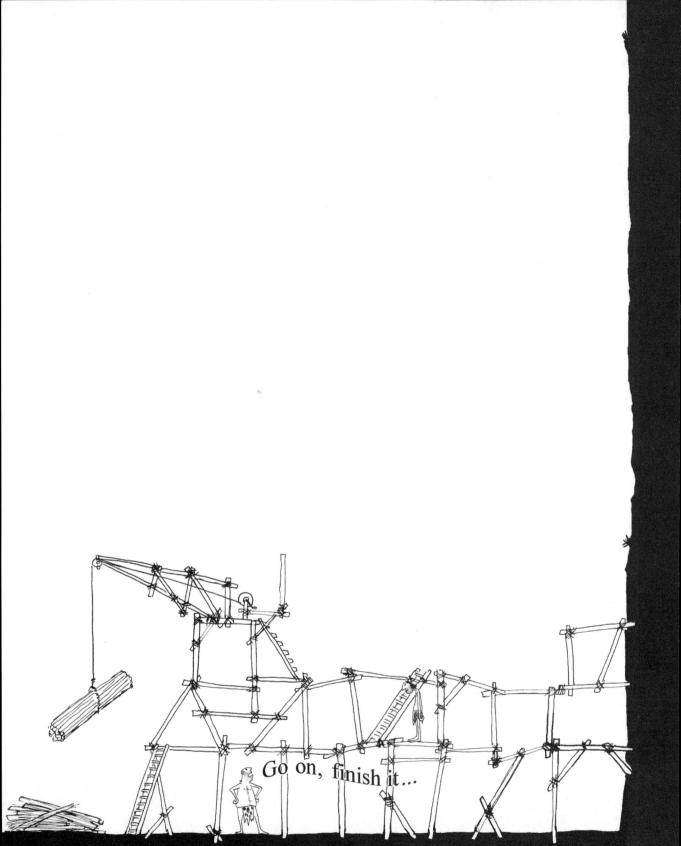

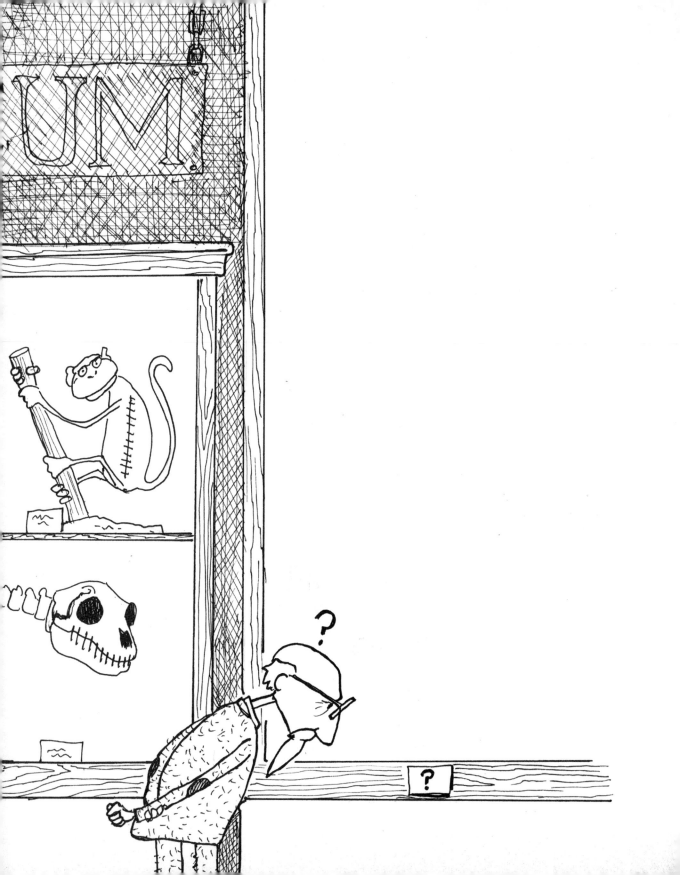

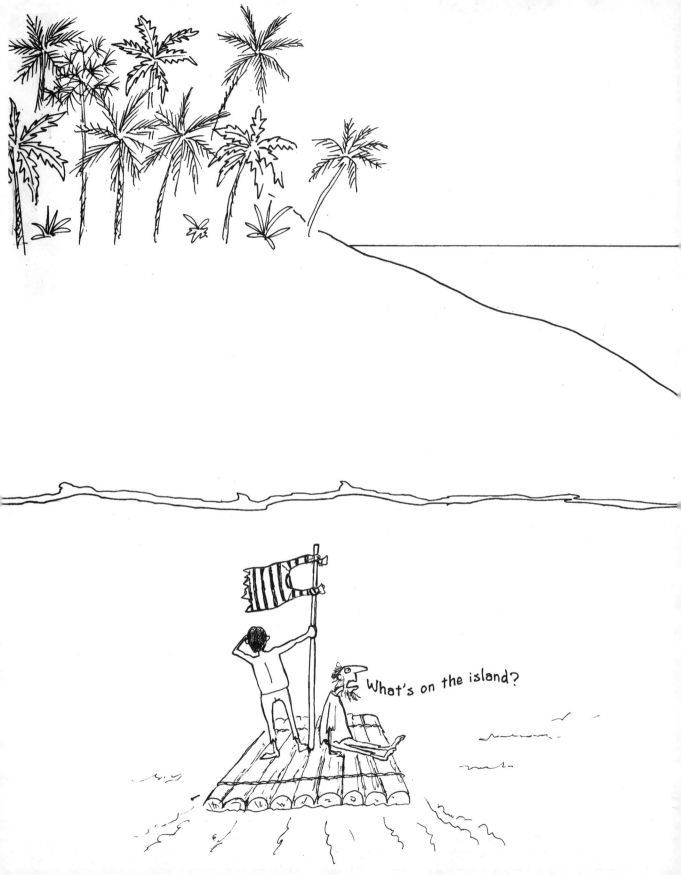

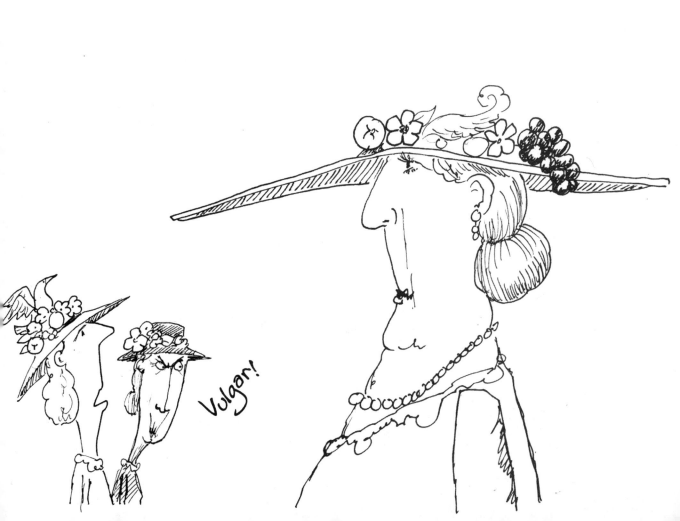

Come on, chop-chop, get it finished!

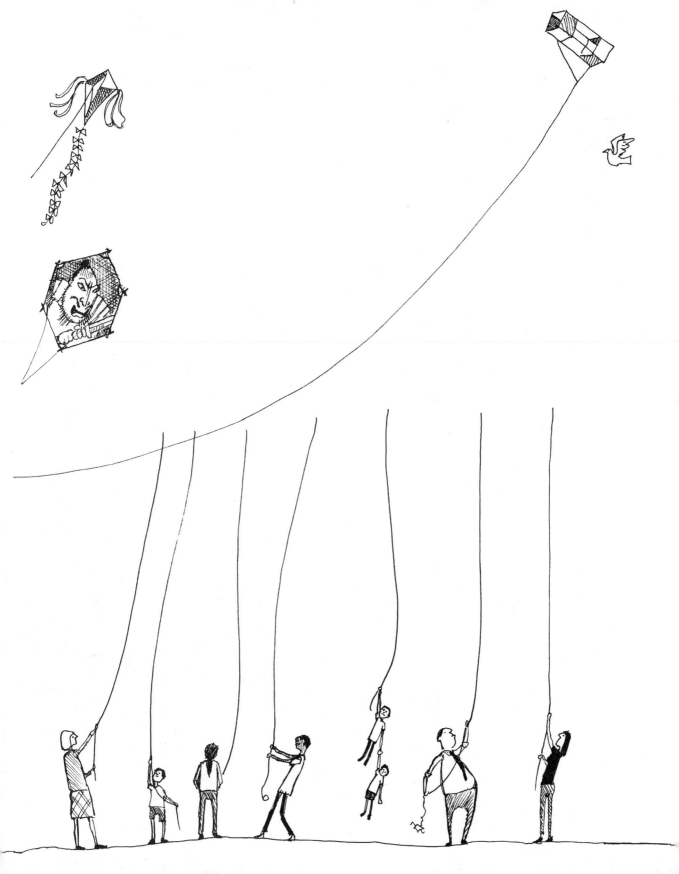

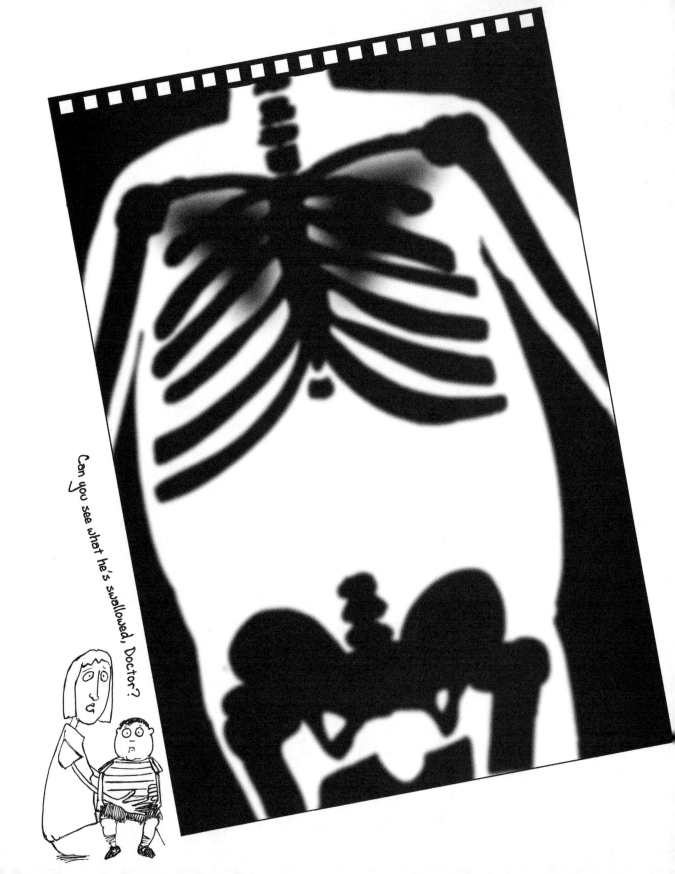

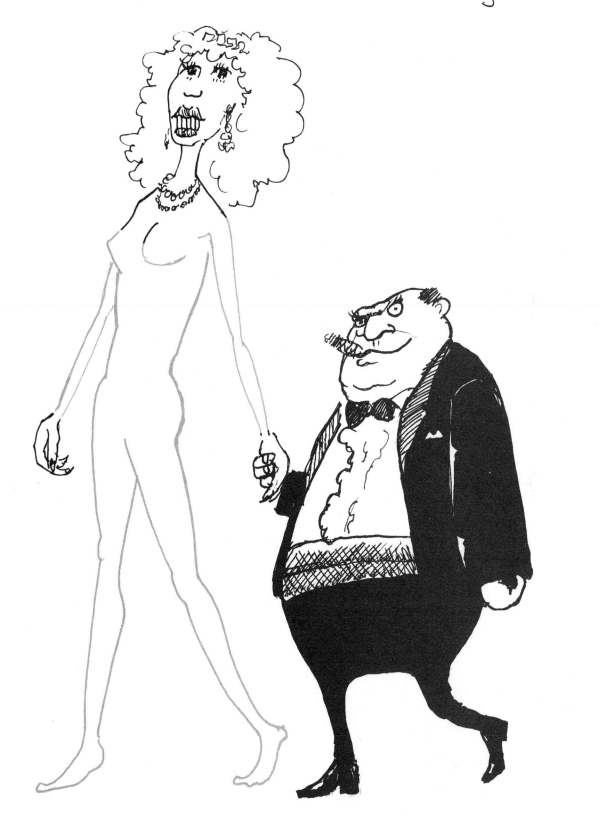

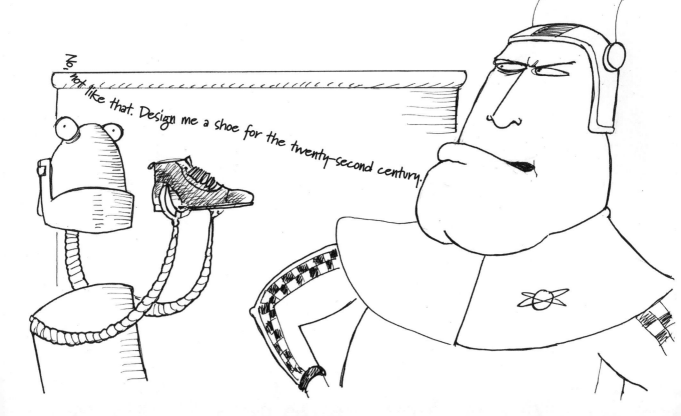

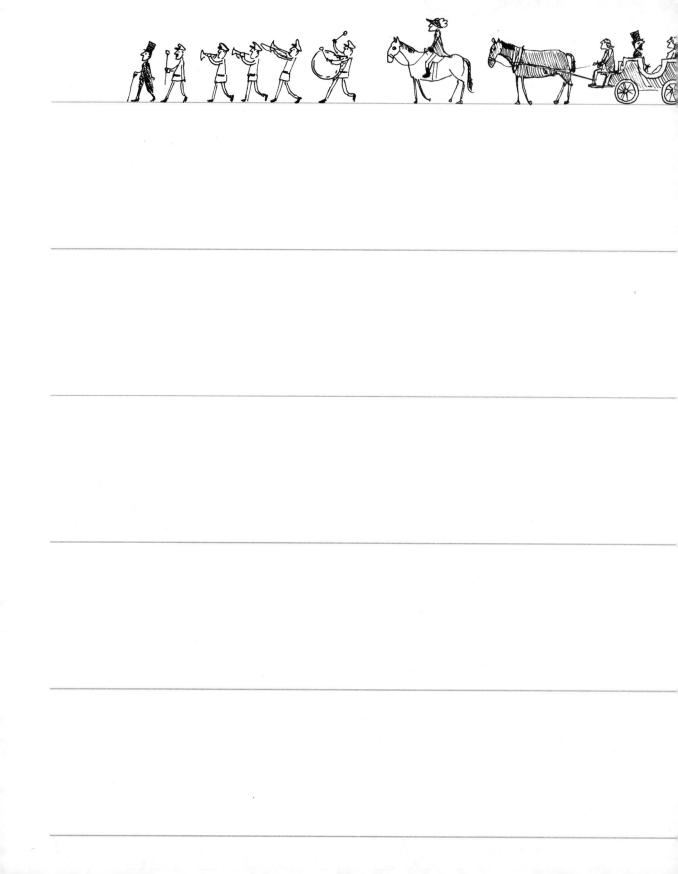

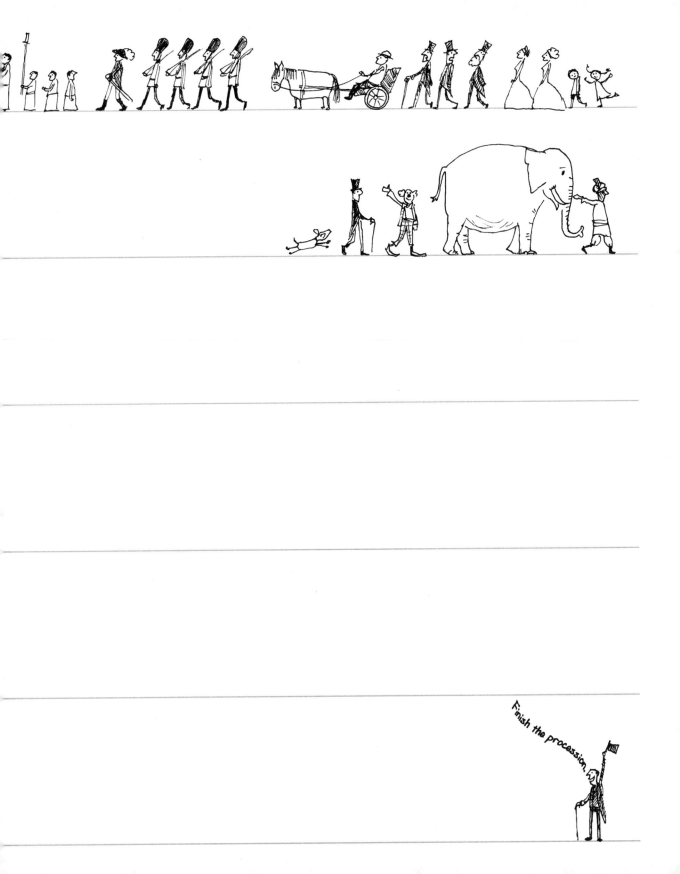

Finish the procession.

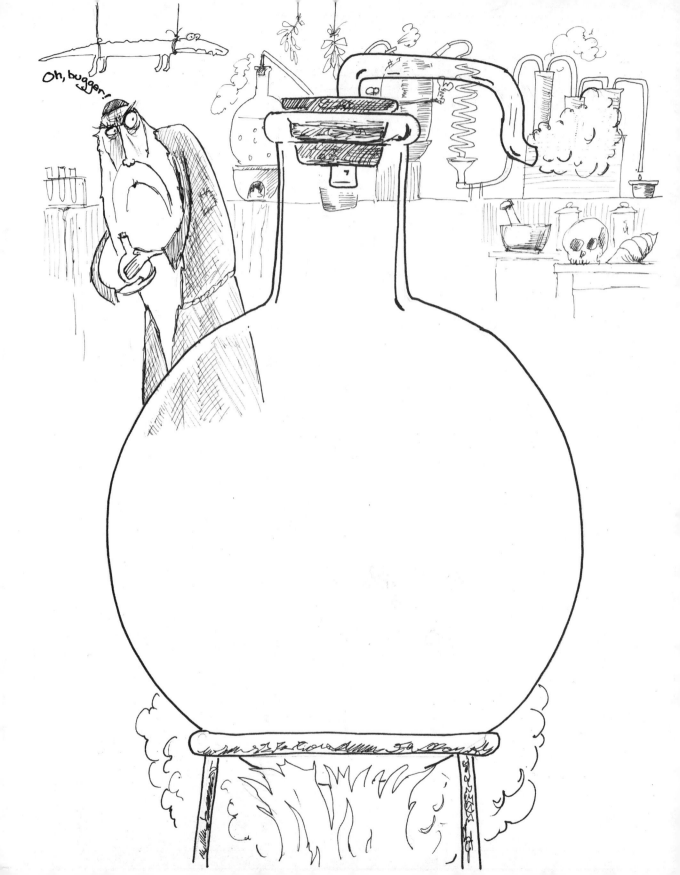

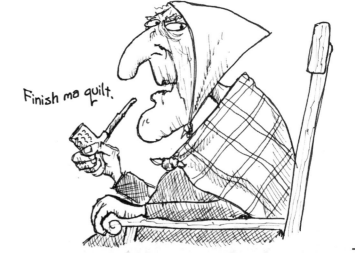

Finish ma quilt.

Stripes please.

How many sunbathers on the beach?

Very clever, now fill the page.

I'm the doge, so finish my palace.

What have we eaten?

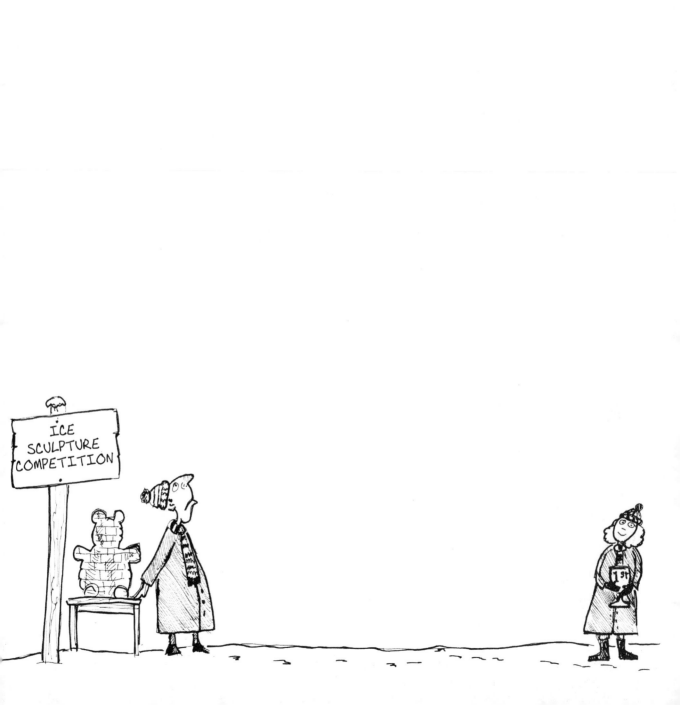

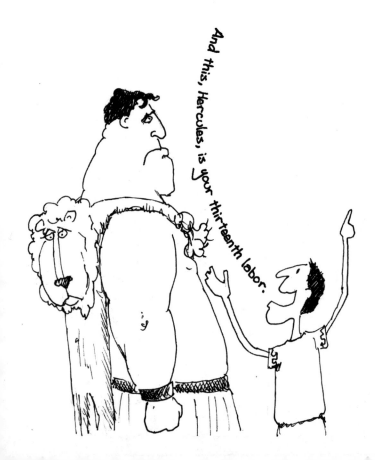

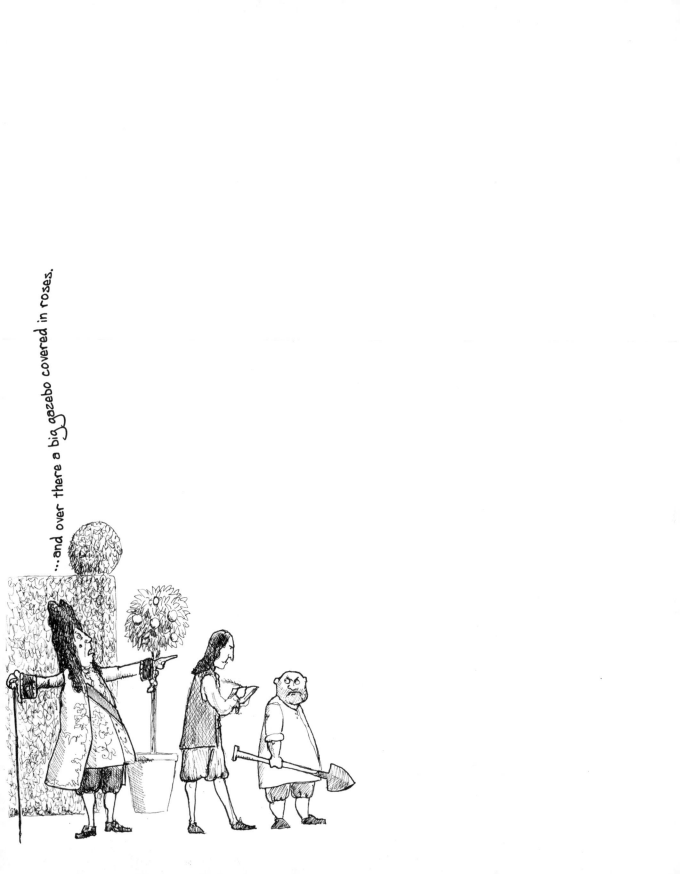

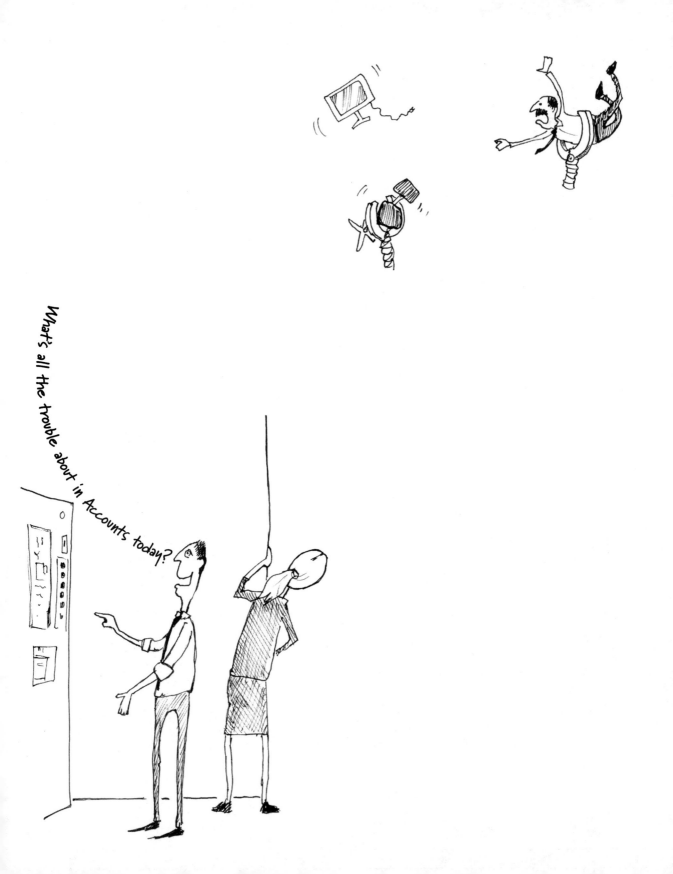

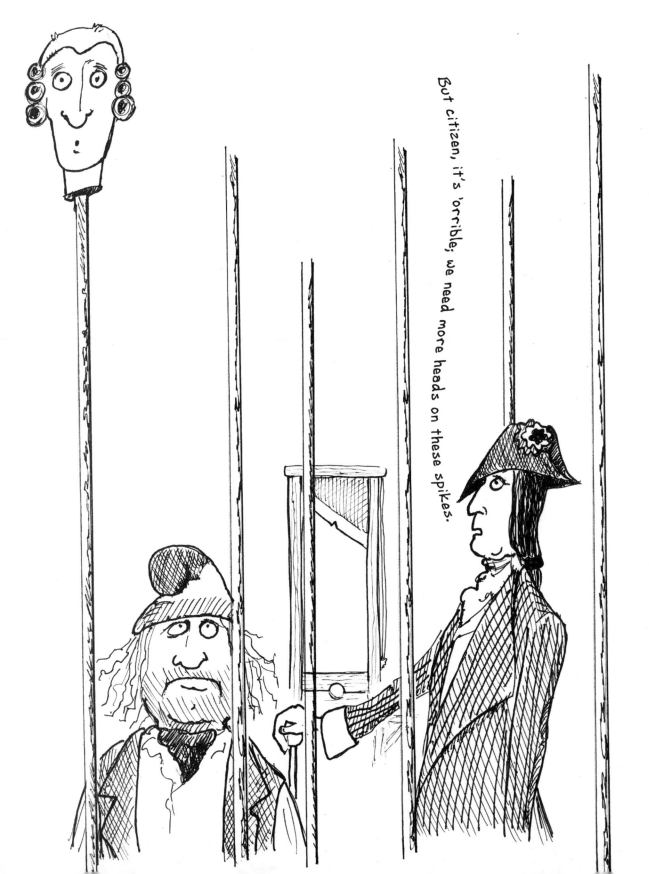

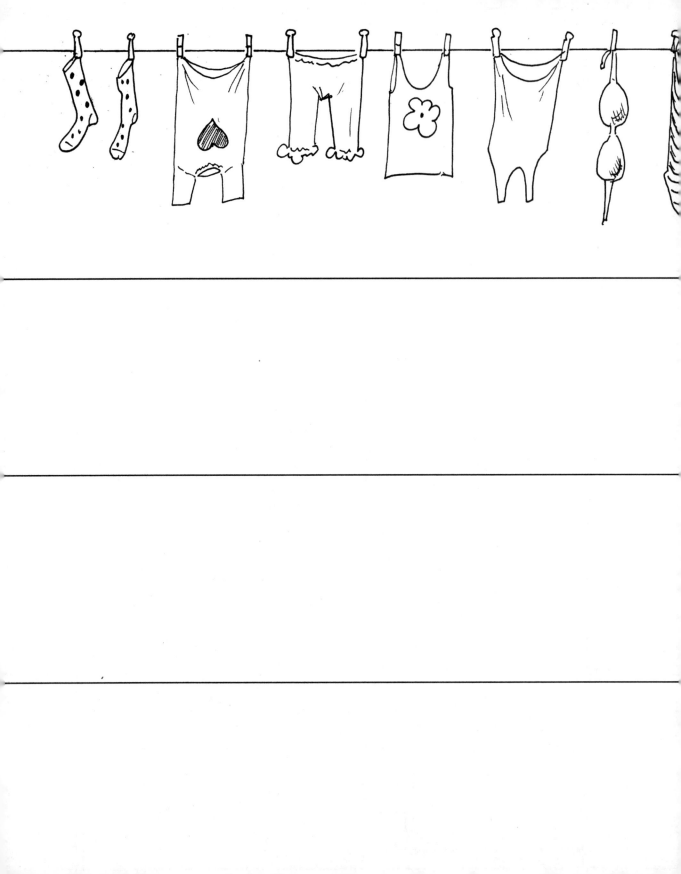

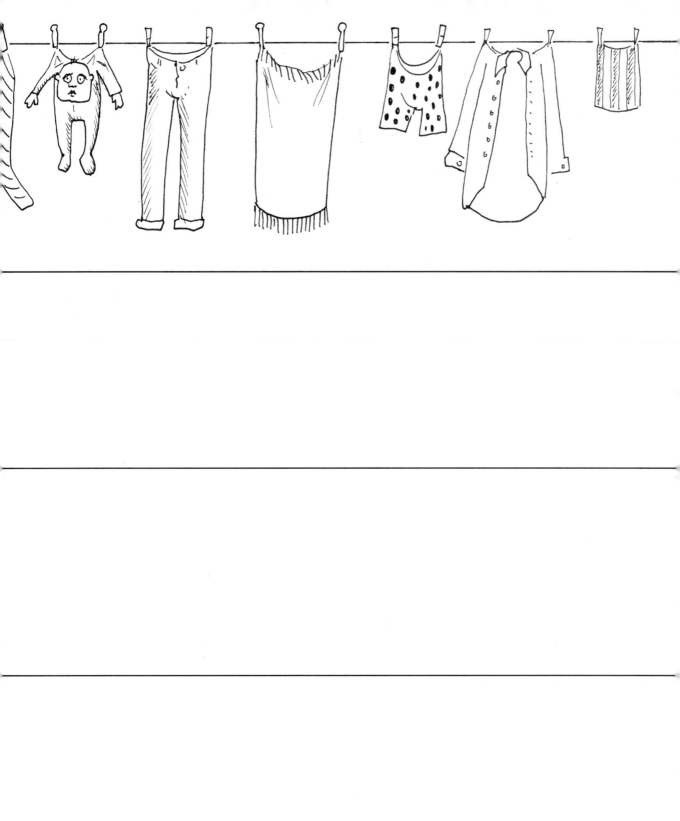

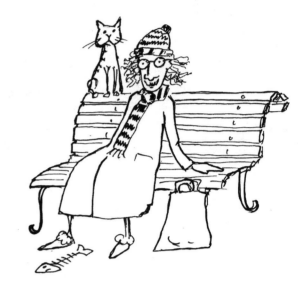

How many cats has the cat lady got today?

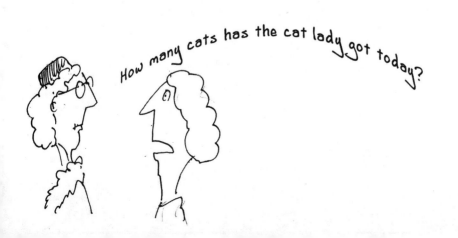

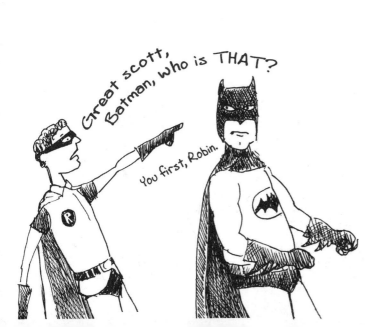

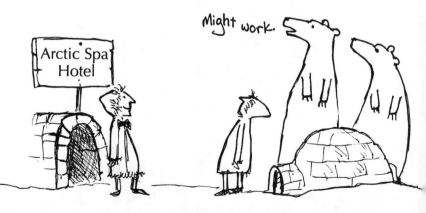

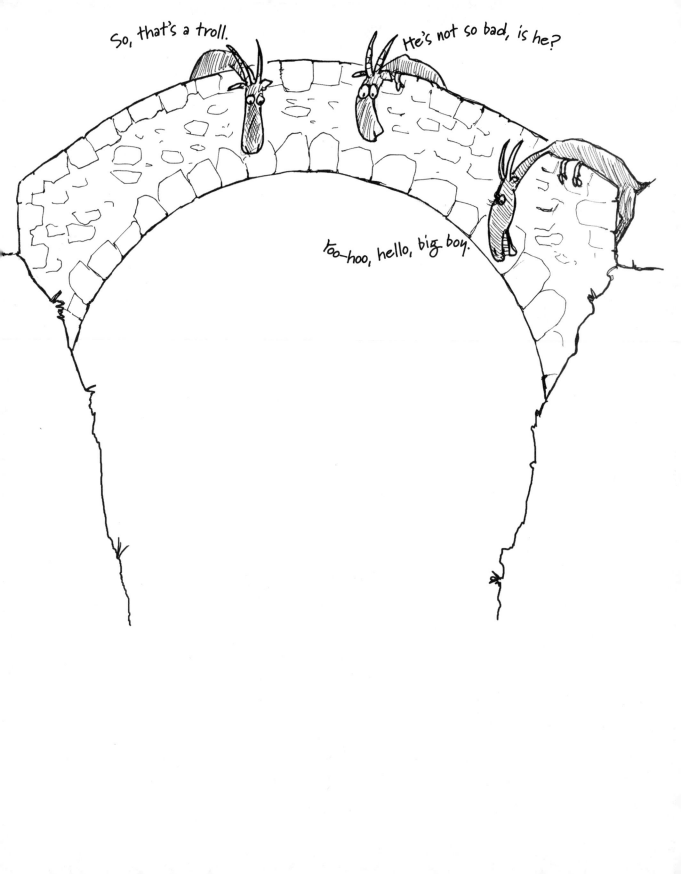

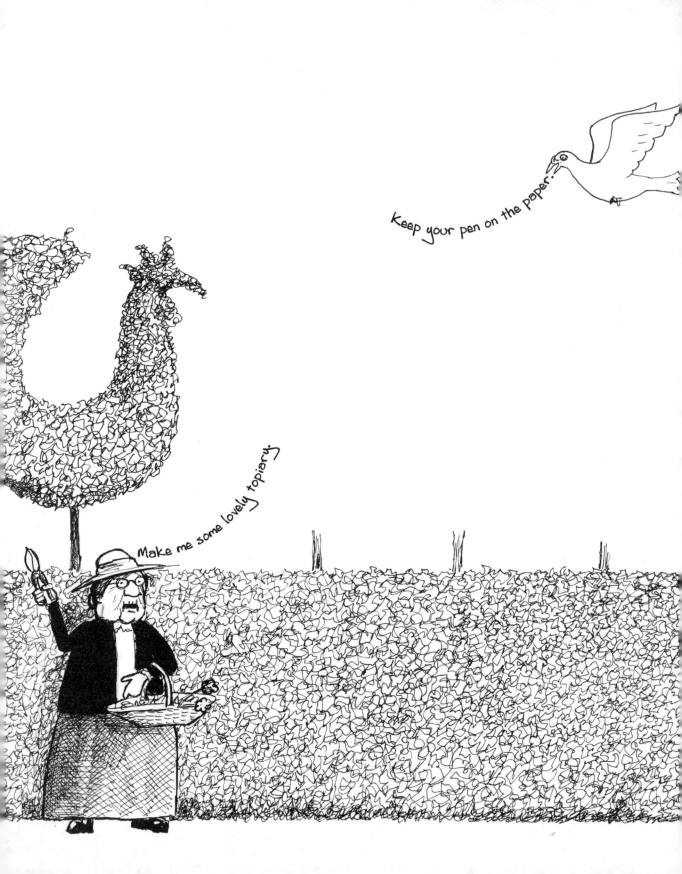

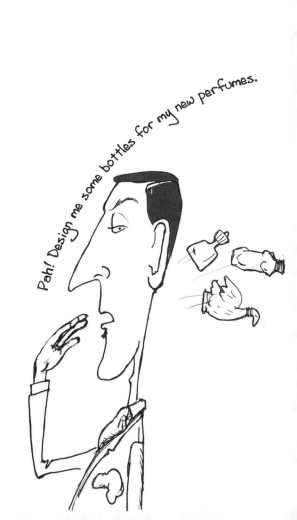

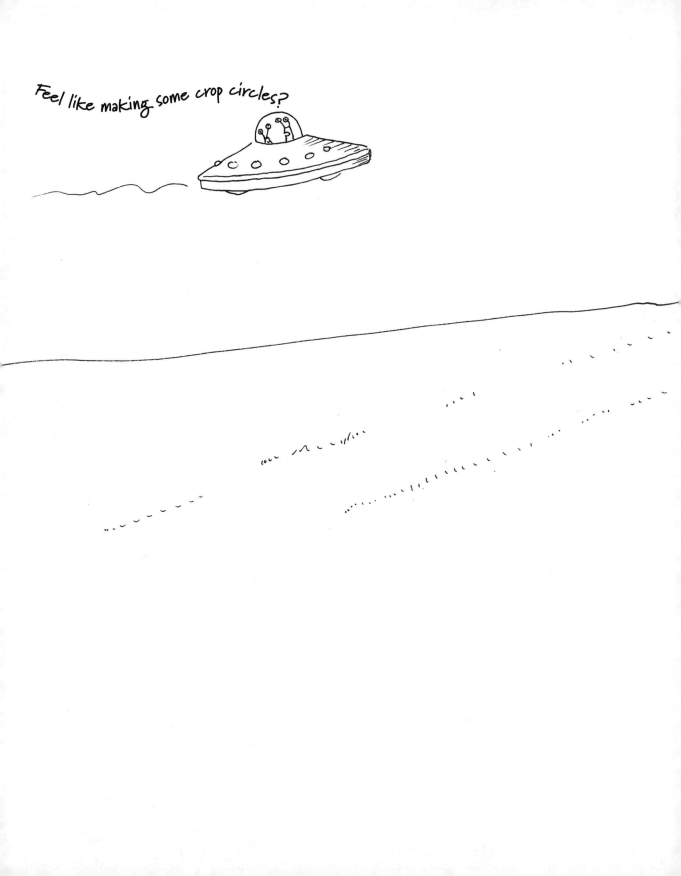

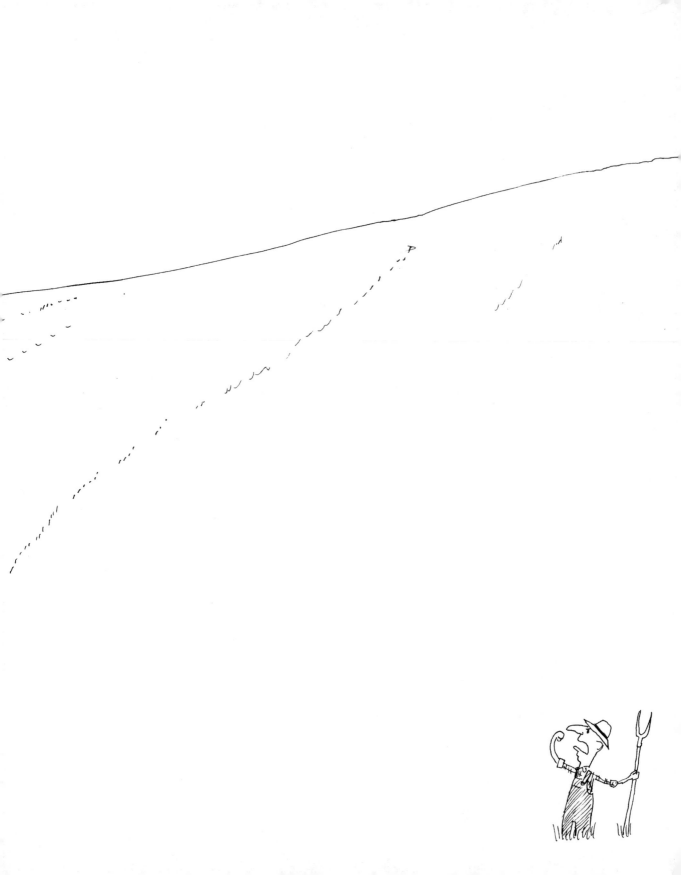

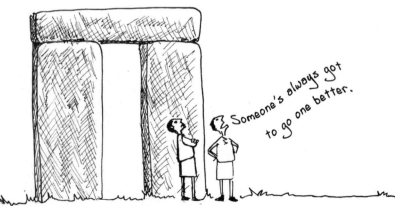

Someone's always got to go one better.

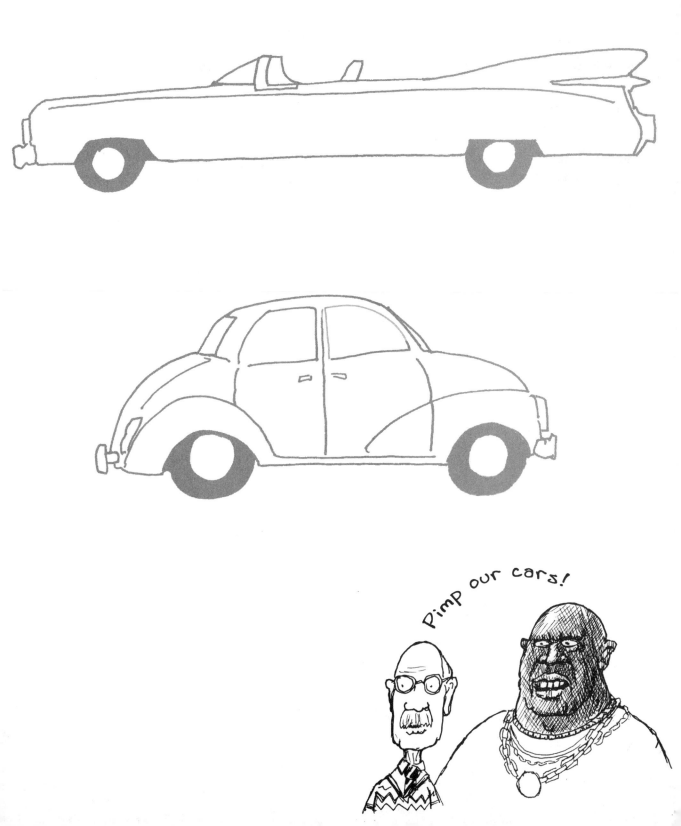

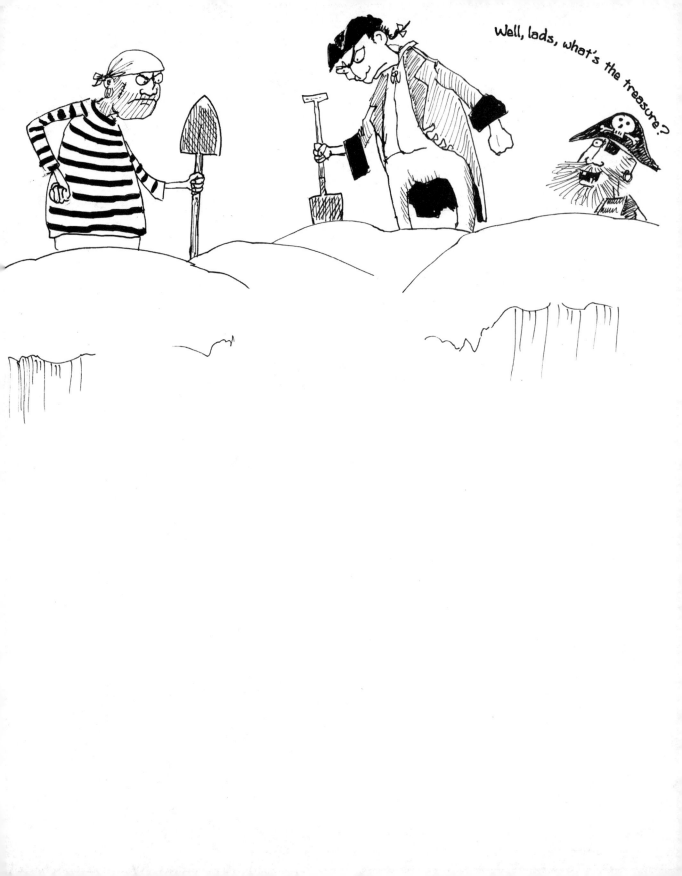

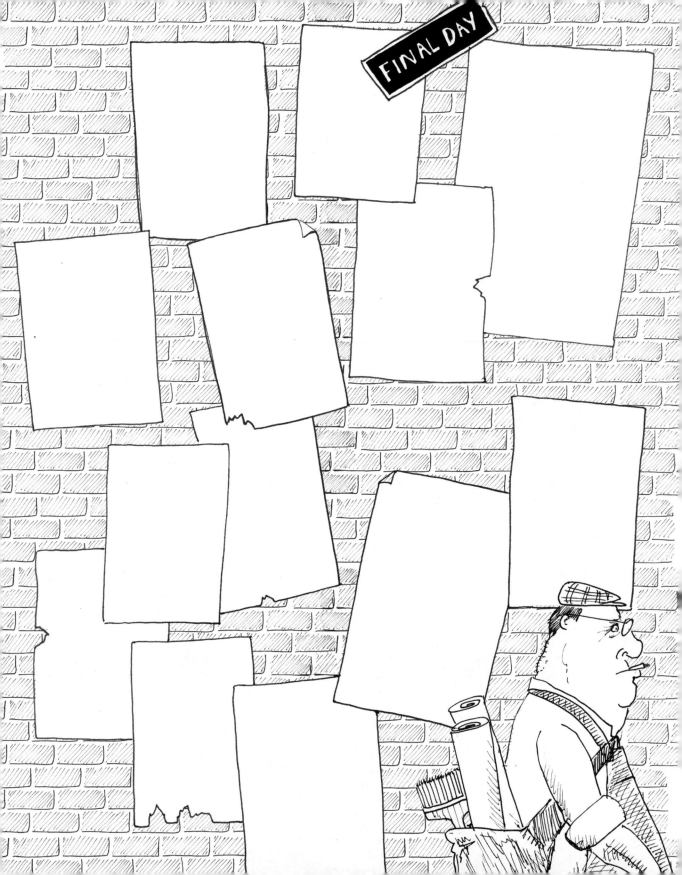

PUMPKIN
COMPETITION

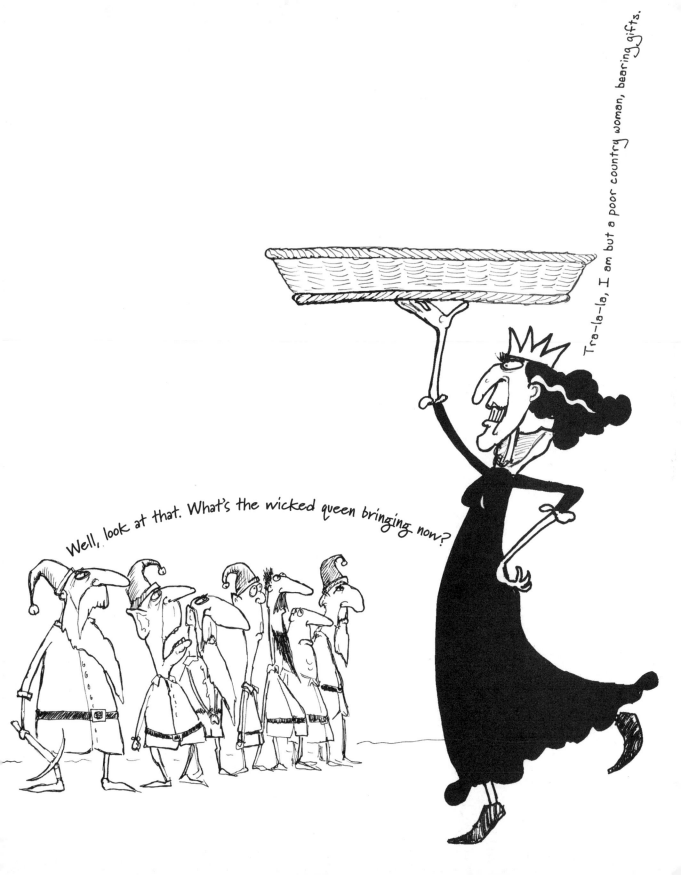

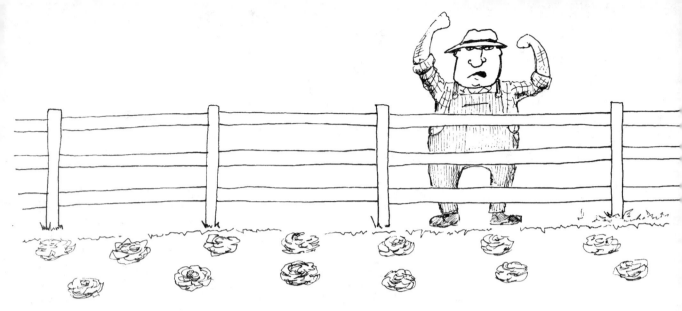

Quick, he hasn't got his gun; everyone into the field!

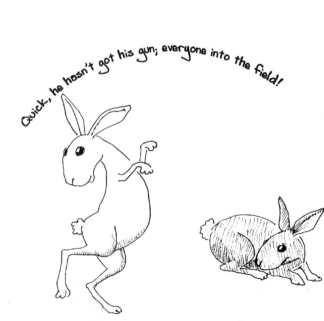

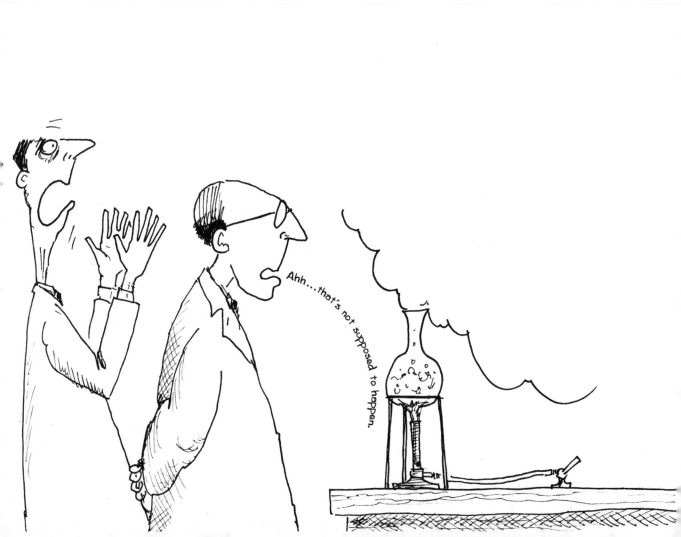

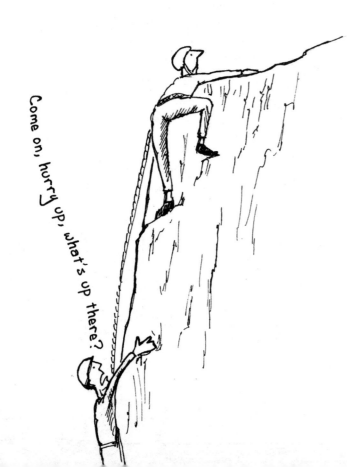

Come on, hurry up, what's up there?

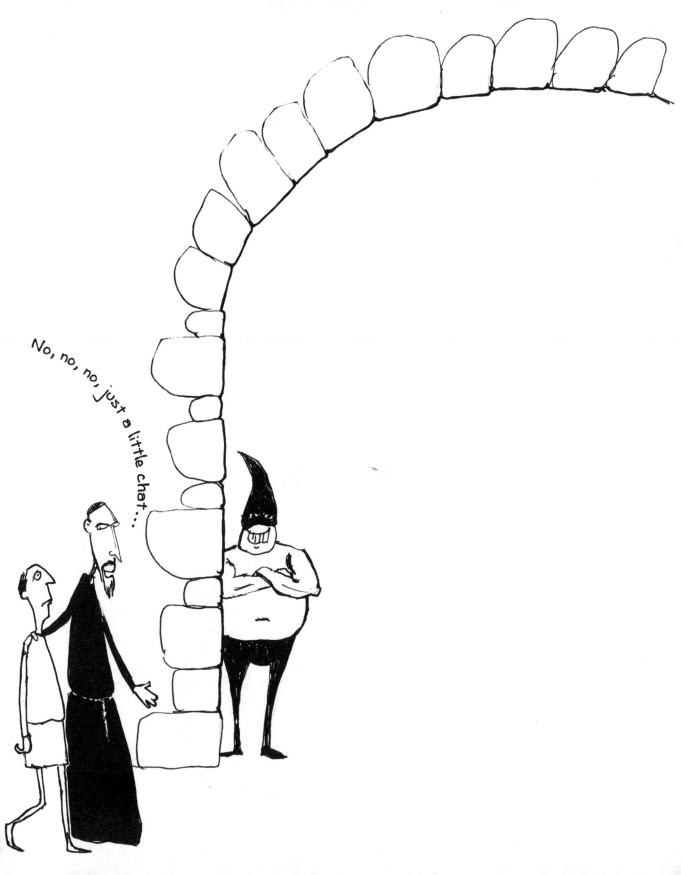

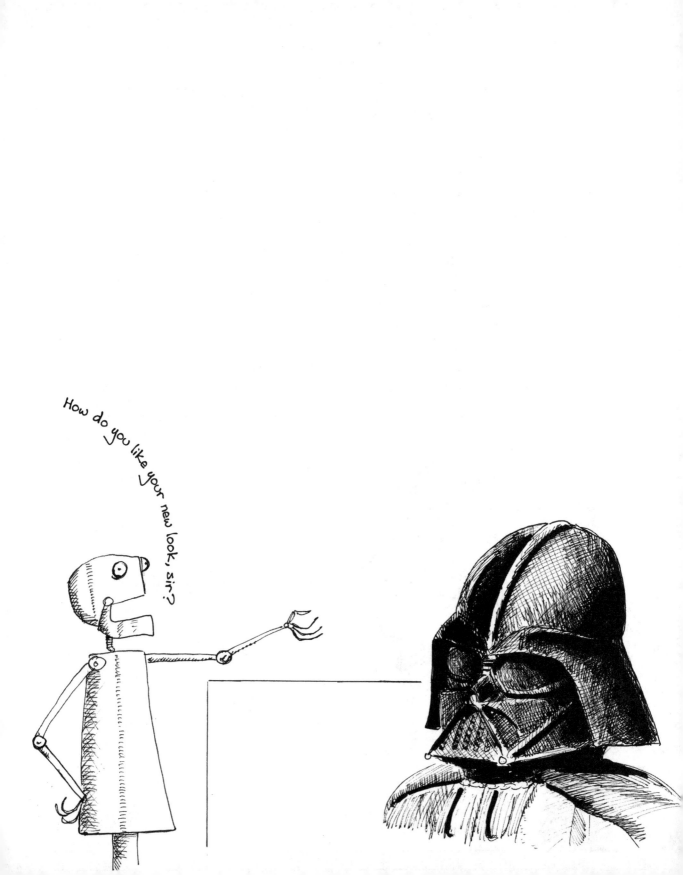

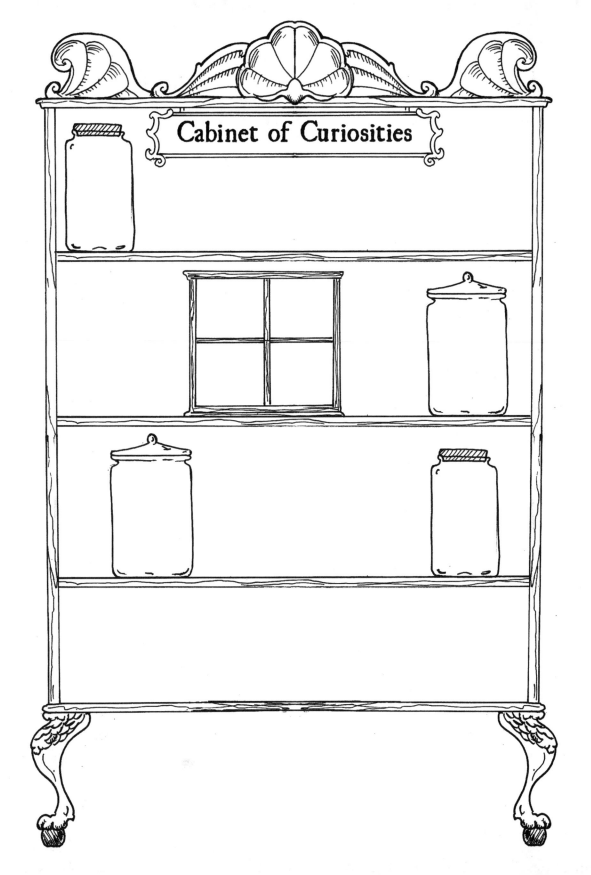

Cabinet of Curiosities

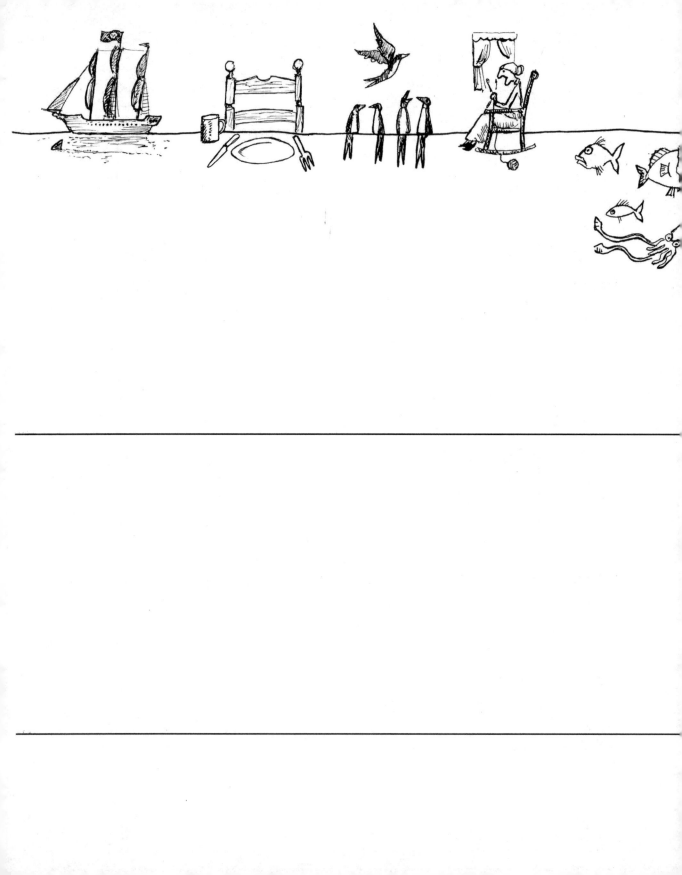

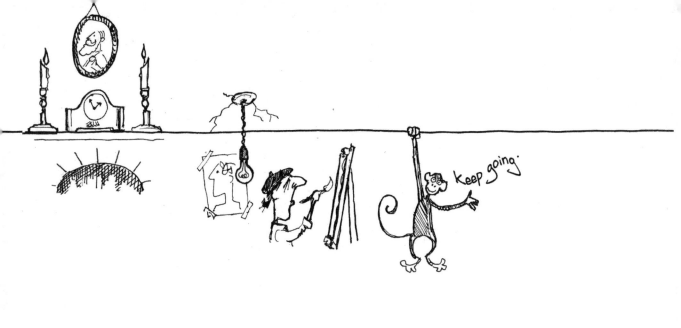

keep going.

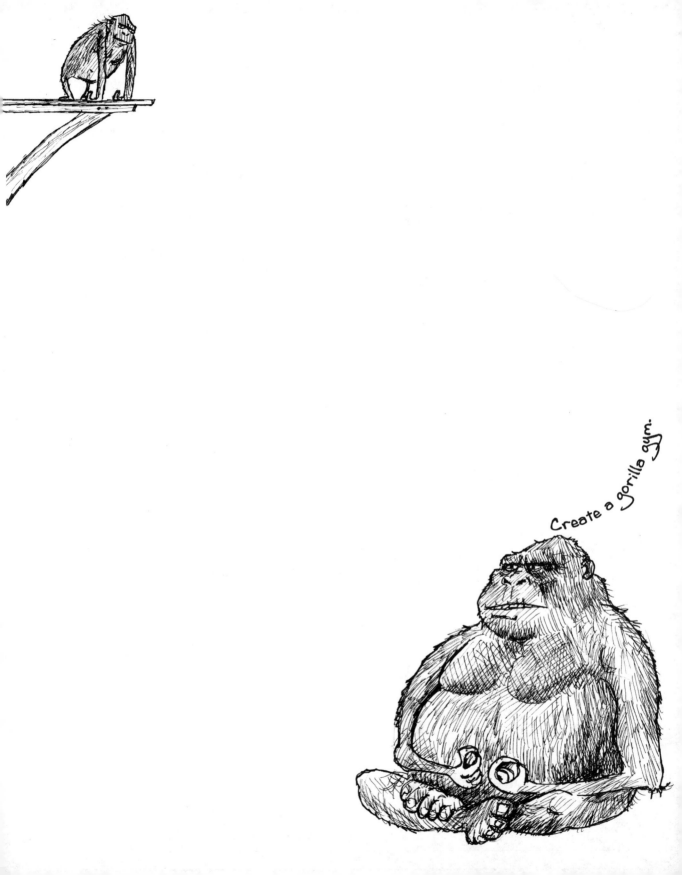

Create a gorilla gym.

Doodle on your own!

Doodle on your own!

Doodle on your own!

Doodle on your own!

Doodle on your own!